IMAGES
of America

HOOD RIVER

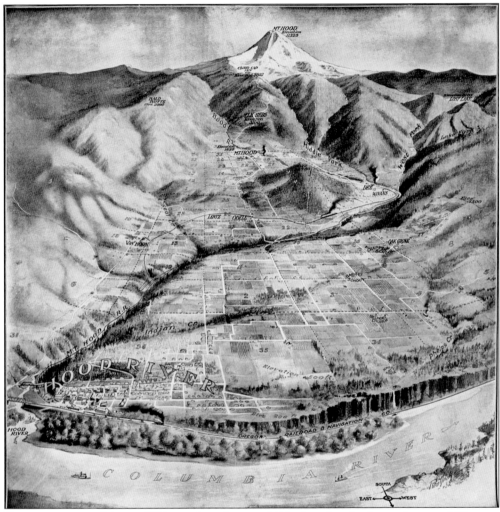

Various versions of this c. 1910 map have been published and revised over the past 100 years. This version shows the elevation of several valley areas as well as Mount Hood. Also shown is the Mount Hood Railroad going south towards Mount Hood and the Oregon Railroad & Navigation Company tracks along side the Columbia River. (Courtesy of the History Museum Photo Archive Collection.)

ON THE COVER: This glass plate negative invites the viewer to step back in time and experience the excitement of one of the first Hood River Valley agricultural fairs. It can be deduced that this picture was taken prior to 1908 because the sign says Wasco County. Hood River separated from Wasco County in 1908, becoming the second smallest county in the state of Oregon. This tent structure was most likely erected specifically for this occasion near the railroad tracks. Even though this event was to showcase the fruit of the valley, it must have also been a very special social outing, based on the attire worn by the visitors. Imagine what could be seen inside for only 15¢. The horticulture fair was held every other year between 1892 and 1910. Generations later, the Hood River County Fair still thrives during the fourth week of July. (Courtesy of the History Museum Photo Archive Collection.)

IMAGES
of America

HOOD RIVER

Connie Nice and the
History Museum of Hood River County
Foreword by Mayor Arthur Babitz

ARCADIA
PUBLISHING

Published by Arcadia Publishing
Charleston, South Carolina

Printed in the United States of America

Library of Congress Control Number: 2012945309

For all general information, please contact Arcadia Publishing:
Telephone 843-853-2070
Fax 843-853-0044
E-mail sales@arcadiapublishing.com
For customer service and orders:
Toll-Free 1-888-313-2665

Visit us on the Internet at www.arcadiapublishing.com

To all the true Hood River historians out there—you know who you are. Thank you for your help in making this book possible. And to my husband, David, for being the solid foundation behind everything I do.

CONTENTS

FOREWORD

I first met this photograph collection when I ducked into the History Museum to escape a sudden downpour. To pass the time, I grabbed a well-thumbed binder of images spanning over 100 years of our county's history. The streetscapes were vaguely familiar, except where there should be coffee shops there were blacksmiths, and the traffic consisted of horses and carriages. The people could easily be my neighbors, except for their clothes.

I am not sure why it is so much fun to look at old pictures, but I have yet to find anyone who is not drawn to them just a little. For me, these images help to imagine what it was like to live in a time when Hood River was at the frontier—when hardy souls were laying the foundations for the modern agriculture, manufacturing, and commerce of our valley. These images show a time when every visitor had to have a mix of determination and wealth to get here. In them are clues about how our community has developed and, perhaps, some insight into its future path.

I am thrilled to see this collection shared with the world, even as the History Museum works to preserve it for future generations. Rainy day or not, each one of these images is worth taking some time to explore.

—Arthur Babitz
Mayor
City of Hood River

ACKNOWLEDGMENTS

This book has only been made possible by the contribution of hours of volunteer service from members of our entire community. I especially want to acknowledge Arthur Babitz and Matt Carmichael, who have, for the past two years, been digitizing the History Museum's photograph collection, thanks to a generous grant from Google and the Oregon Heritage Commission. Their hours of pouring over fragile photographs and glass negatives and then transforming them into digital files laid the groundwork for this publication. In addition, I want to thank Bill Pattison, Sally Donavon, Casey Housen, and the thousands of daily visitors to our historical photograph blog who have shared their personal stories, references, and comments. Their input, clarifications, and reflections have brought a deeper connection between these images and our community's history. Thanks also to Carol Ann Faull and Dee Durham (my mom), who read hundreds of text copies searching for grammatical errors. I also graciously acknowledge Ruth Guppy, historian, author, and writer for the *Hood River News* from 1928 until 1960. She passed on in 2002 but left behind 32 years of "Across the Picket Fence" columns and *Panorama* articles that have inspired the text and photograph captions of this book. Her personal writing notes were donated to the museum at her request and were used extensively in the creation of this manuscript. To quote Ruth from an article dated April 7, 1960, "some folks yearn for those 'good old days' when the valley claimed artists, musicians, scholars, retired army officers and gentlemen ranchers from wealthy eastern families. We say that by any standard Hood River still has as varied, as interesting, as individual and as talented a population as any community its size."

To the best of my knowledge, the History Museum owns rights to all images included herein, unless otherwise credited. Where applicable, the specific History Museum collection to which each image belongs is noted. For information on purchasing prints of these images, contact the museum (541) 386-6772 or thehistorymuseum@hrecn.net, or visit www.co.hood-river.or.us/museum. Visit our photograph blog at www.historichoodriver.com.

INTRODUCTION

Charles Dickens said, "nature gives to every time and season some beauties of its own; and from morning to night, as from the cradle to the grave, it is but a succession of changes so gentle and easy that we can scarcely mark their progress." So is it with the passing of time, the turning of the clock, and the changes of seasons within our community. Hood River's past, present, and future are forever linked with the seasons. Whether it is the change between spring and winter, the span of time between blossom and harvest, or the marking of generations from birth to death, everything and everyone honors the passing of time by seasons.

In the beginning, it was the native people whose lives were linked as one with the land and the seasons. Spring brought the melting of winter snow, which gave way to fresh new plant growth and renewed life in the forests. In the summer, it was the salmon run and camas roots that provided valuable sources of food that could be dried and saved for coming seasons. By fall, tribal members began to harvest huckleberries, nuts, and roots to prepare for the approaching winter. And with the blanket of winter upon them, it was time to tell stories and pass on legends and life to the next generation. As two of the first white explorers, Lewis and Clark noted a Native American encampment of about 30 lodges on the west side of the valley located on a sand bar. The village was called Pollala Illahe. The Hood River valley served as a trading hub and place of crossings and gatherings for many of the tribes throughout the Mid-Columbia basin. The people lived their life with and by the seasons, and that life would be forever changed with the coming of a new season: that of settlers.

The earliest recorded settlers, the Laughlin and Farnsworth families, arrived in 1852. After the first severe winter, they abandoned their claims and returned to The Dalles, Oregon. In 1854, Capt. Nathaniel Coe, with his wife and four sons, chose this place for their permanent home and filed a donation land claim, part of which was platted for the town site of Hood River in 1881. It was Mary Coe who was reportedly responsible for changing the name of Hood River from its earlier moniker of Dog River, which she felt did not present an inviting impression to cultured easterners looking for places to relocate at the turn of the century.

But come they did, from around the globe. Finnish, German, and Japanese immigrants made the arduous journey to Oregon in search of rich soil and abundant land. By 1883, Hood River was on the map with a few stores, a railroad station, and a bridge that spanned the Hood River to allow access to the central downtown core. Smaller communities, including Odell, Frankton, and Parkdale, began to spring up. Hood River boasted the only post office in the area, which also serviced friends across the Columbia River to the north, the mail being carried by an Indian in a canoe. Soon hotels, schools, and churches dotted the landscape. As the spring of progress arrived, it signaled the winter of life for the Native Americans. By 1910, the census showed only 15 Native Americans living in Hood River County. Ruth Guppy wrote, "out of fragments told by Hood River pioneers came glimpses of a people dying with what dignity was left to them, stoically accepting their unhappy fate." With the decline in the native way of life came a brand-new season, filled with fruit blossoms and apple harvests.

The first fruits planted were strawberries, which thrived in the warm summer sun and provided a valuable revenue source to keep farmers going until the apple trees were developed enough to produce. Clark's Seedling berries were a red jewel among strawberries, quick to ripen and easy to grow. They also had a firmness that allowed them to keep long enough to be transported to Portland, where city folk were eager to add them to their menus. Later, markets opened, and local farmers began to ship by rail into Idaho, Montana, and beyond. The strawberry set the stage for future successful marketing of local apples. If Clark's Seedlings were so superior to any other berry variety grown at that time, then so must the Newtowns, Spitzenbergs, and other local apples have that special Hood River quality. The season of bountiful harvests had begun. The great Lewis & Clark Exposition of 1905 in Portland launched the Hood River valley's pitch to reign supreme in the world with regard to all things fruit. It was a boom season resulting in an upward surge in population, as well.

But orchard life was not easy. Tough winters, insects, and fluctuating consumer markets eventually signaled a shift from apples to pears. The Hood River name is still synonymous with quality and perfection when it comes to fruit, and Hood River County currently produces more pears than any other place in the world. It has been a long season from those first seedling trees planted by E.L. Smith in 1876, and it appears the next season on the horizon includes microbreweries and wine production.

People and seasons have come and gone. Still, changes are reflected with the turn of each calendar page. Once again, Hood River has found its way into the hearts and minds of the world, and it is all about pears, wine, beer, and wind.

Blossom petals float across the valley in April's wind, followed by windsurfing and kite sailing in July, which give way to the harvesting of grapes for wine in September. Cold December is filled with snowboarders and skiers. The passing of seasons continues to serve as the life force of everything and everyone who lives and visits in the beautiful Hood River Valley.

One

SEASONS

TIME PASSING

Land of the bunch-grass bright with green
In the day of long ago;
Ere the plowshares trace was seen,
Or the golden grain did grow.
O'er all these hills the bunch grass grew,
Marked by Indian trails alone;
All their bounds in youth I knew,
When their native beauty shone.

—C.C. Masiker
excerpt from "The Land of Bunch Grass"

Prior to the westward movement, the landscape of the Columbia River Gorge and the surrounding foothills of the Cascades were covered with tufts of grass called bunch grass. The roots of these species bore deep into the volcanic soil, aiding in slope stabilization. These drought resistant plants also provided habitat for insects, small birds, and animals. The Native Americans of this region utilized bunch grass for basket weaving. It is hard to imagine today how different the countryside would have looked with roaming herds of elk and deer, soaring bald eagles, and bunch grass.

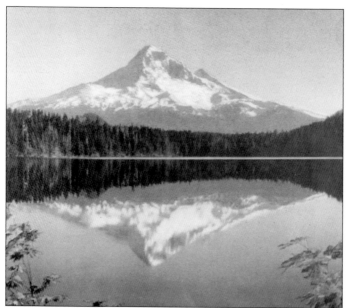

The majestic Mount Hood is the iconic symbol of Hood River County. As Oregon's highest mountain peak, it has inspired many tribal legends, the most commonly known being from the Multnomah tribe, who called the mountain Wy'East. The present name was given by Lt. William Broughton in 1792 in honor of the British admiral Samuel Hood. Lewis and Clark noted this impressive peak in their journals on October 18, 1805. (From the Henrietta Wilson Collection.)

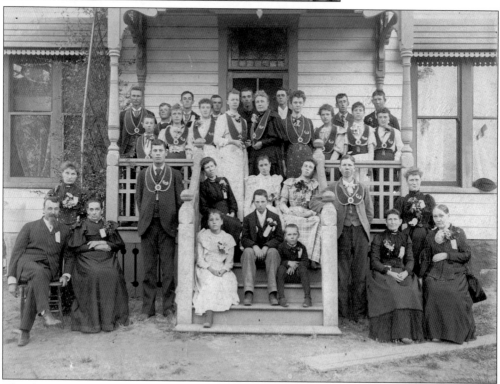

This family is posed in front of the Potter house, located at 4095 Belmont Avenue. The home still exists today, complete with the ornate wood detailing seen in this image. Miles Potter, from Pennsylvania, came to Hood River with his wife and family after the Civil War with the Mansfield Pacific Colony led by Rev. Henry S. Parkhurst. The year was 1875. Potter built this two-and-a-half-story home with 18 rooms and colored-glass windows in the front door and transom. The house brought a bit of East Coast architecture right here in Hood River County.

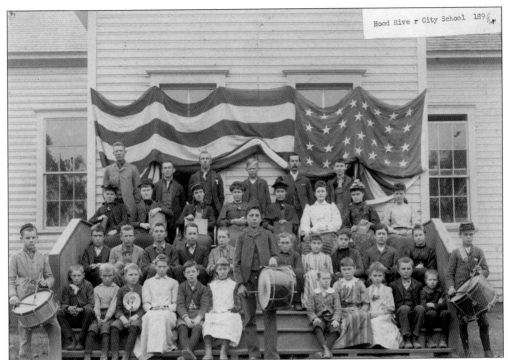

This early 1898 image shows the Coe School when it was located on State Street (the site of the current courthouse). With student surnames that include Wishart, Copple, Rand, Ollinger, Slocum, Bartmess, and Champlin, one can get a small glimpse of the variety of ethnic backgrounds represented by the first white settlers. Note the large flag in the background. The Civil War "Coe" flag was sewn by early townswomen and flew for the first time on July 4, 1861. It now resides in the permanent collection of the History Museum.

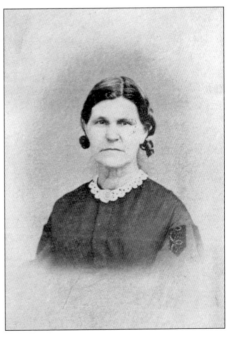

At the age of 53, Mary Coe came west with her husband, Nathaniel Coe, when he was appointed by Pres. Millard Fillmore as a special postal agent in the Oregon Territory. With very few settlers in the area, the Coes became friends with the local Natives, with whom they traded goods for deer and wild fowl. Mary is credited with changing the community name from Dog River to Hood Vale and, finally, to Hood River, hoping to make it more appealing to families considering the arduous journey west to take up land claims in the Hood River valley. And come they did.

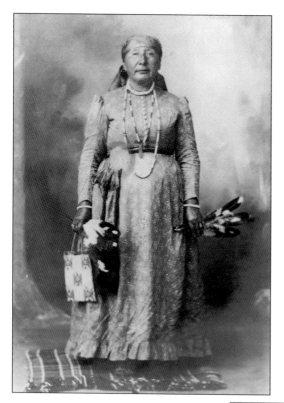

This image of Martha Aleck was taken by a friend in 1898 for her husband, Joe. The Alecks were much loved and respected by all in the early community of Hood River. Joe carried mail from Hood River across the Columbia River to Washington, and Martha walked to Hood River daily to work as a housekeeper in the hotels and also picked strawberries during harvest season. Martha passed on in 1937, but her beautiful collection of beadwork lives on at the History Museum thanks to a donation by the Bunnel family, close friends of the Alecks.

From the Cascade tribe, Chief Henry Charley of Hood River was very involved in the fight to regain fishing rights for tribal members after the river was changed with the completion of the Bonneville Dam in 1937. In recorded minutes from a meeting in 1939, Chief Charley stated that, before Bonneville, "there would be from 180 to 200 Indians camped in this vicinity at one time when the fall run of fish was on." He estimated that, on average, 100 tons of fish were being caught. He would have been deeply saddened by the later construction of The Dalles Dam in 1957, which changed the salmon run in the Columbia River and tributaries forever.

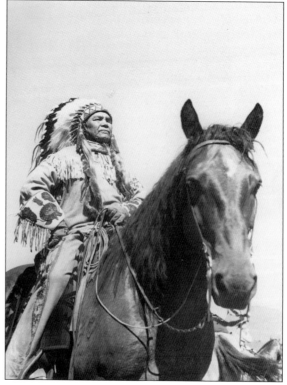

Known to early pioneers as "Indian George," George Tomileck Chinidere was considered one of the last native tribal members in the Hood River valley. George took pride in his ability to forecast the weather and was especially accurate in predicting very cold winters. Smiling, he would say of his predications, "white man pile up plenty wood!" He was killed by a train in 1917. For years, Mount Chinidere near Benson Plateau has been the weather divide of the Cascade Range in the Columbia River Gorge. It was named for George because of his weather predictions.

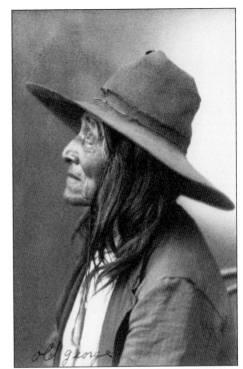

"Indian" Nellie came to Hood River from the Cascade tribe as a bride. She worked for local settlers until rheumatism rendered her disabled. Under threat of being moved to a poor farm, she begged to stay, saying, "these are my mountains, this is my country, these are my people." Her friends helped raise funds to build her a small cottage at Alma Howe's Cottage Farm, where she lived until her death in 1914.

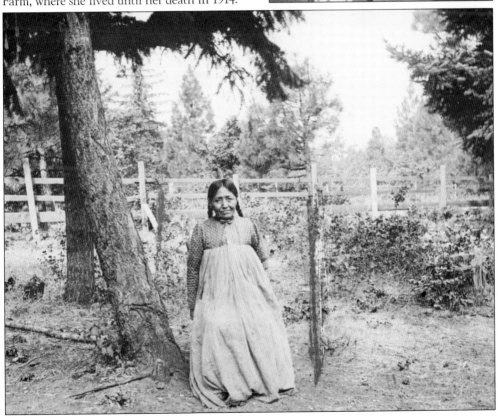

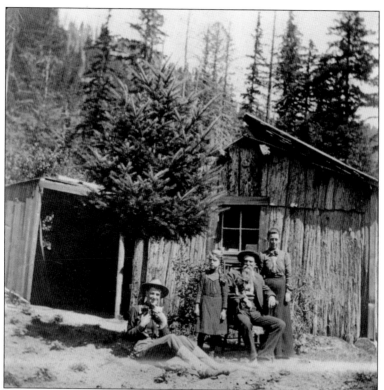

This early-1900s image shows the Buskirk family, early homesteaders on the West Fork. Pictured are, from left to right, Lewis Stephan Buskirk (seated on the ground, holding the kittens), Stella Mae Buskirk, John Buskirk, and his wife, Anna Vertrees Buskirk. John was a Civil War veteran, having served in the Missouri Cavalry as a private. Note the interesting vertical board walls with the bark still intact.

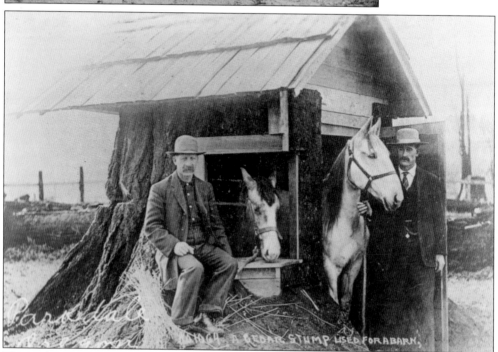

This cedar stump, located in the Parkdale area, is being used as a makeshift barn. Believed to show Sam Hess (left) and his brother, Floyd Hess, this early-1900s postcard image shows a unique use for the huge stumps left from clearing the forest to make way for farmland and orchards.

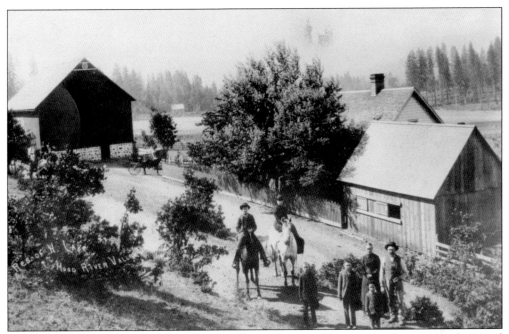

The notation on this picture identifies it as the residence of Hans Lage, who came to the Hood River valley from Germany in 1876. He and his wife, Lena, had 10 children. He was one of the first farmers to plant apples, pears, and peaches. Generations later, this family farm, having persevered through many trials, still remains. It was designated an Oregon Century Farm in 1976.

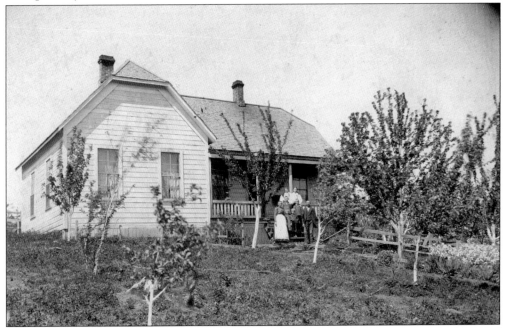

Small communities like Oak Grove, Frankton, and Barrett sprang up in the outskirts of the city of Hood River as turn-of-the-century farms were developed, such as the Chas D. Hayner homestead, shown here in 1885. This family would surely be proud of their large home and the beginnings of their orchard, which can be seen in their front yard.

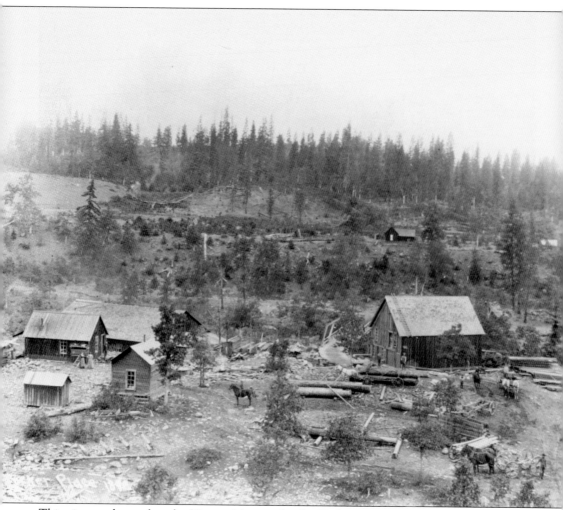

This picture, donated to the History Museum by the Tucker Estate, is an image of the Charles Barton Roba Tucker place, built in 1887. This photograph is a perfect example of the hard work it took to settle in the Hood River valley. Notice the barns, house, and lumber mill, as well as all the people busy at their tasks for the day. The home burned in 1889 and was replaced by a two-story frame building with a long veranda. The farm and mill were located at the south end of Tucker Bridge, about five miles south of Hood River. The Tucker Bridge was a very important crossroads, offering one of the few ways to cross the Hood River to get to the upper valley. It was also used as a stagecoach stop in the late 1880s.

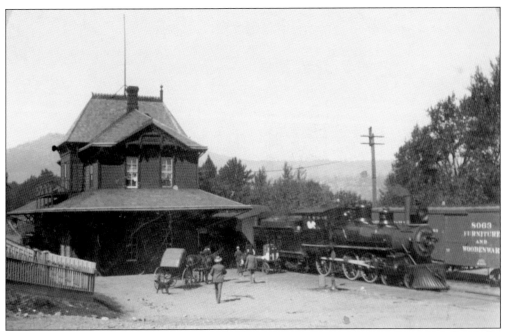

This early-1900s photograph is from a stereoscope card produced by W.D. Rogers. It shows the Oregon-Washington Railroad & Navigation Company train stopped at the Hood River Depot, which it began doing in 1882. Train transportation was vital to both passengers and freight because of the lack of adequate road systems and the difficulty of navigation on the Columbia River, especially to the east, where boats encountered the Celilo Falls and rapids at The Dalles. A new depot was built in 1911.

This photograph, also from a stereoscope card, shows the variety of uses for boats on the Columbia River. Freight, wagons, and passengers are all visible on board, awaiting the beginning of their journey to destinations unknown. On the left is the *Dalles City*, and to the right is none other than the great *Bailey Gatzert*, queen of the river from 1892 to 1917. Both ships were stern-wheeler steamers and were powered by trees cut along the banks of the Columbia River.

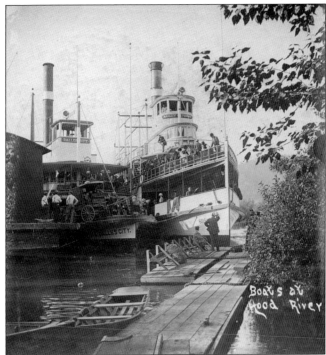

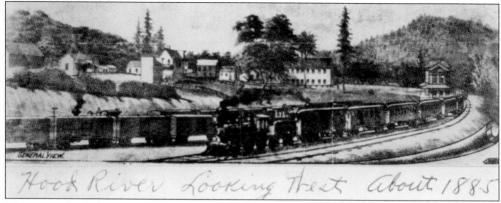

Hood River Looking West about 1885

This pen-and-ink-drawing postcard shows the city of Hood River, looking west, about 1885. Depicted are the railroad and the trains coming and going that provided such an important connection between the community and the outside world. When transcontinental service arrived in 1909, it cost $53.65 (plus $14 for sleeping-car accommodations) to travel from Hood River to Chicago.

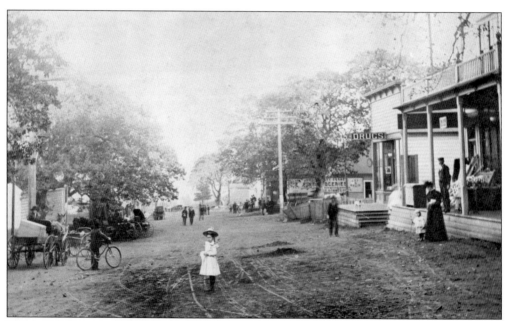

This is Oak Street in 1890. Named for the large number of oak trees, it was the main thoroughfare through Hood River. Even in this early image, one can see the thriving and bustling business community, with a drugstore and grocery store clearly evident. One has to wonder whether this little girl is waiting for something or just posing for the photographer.

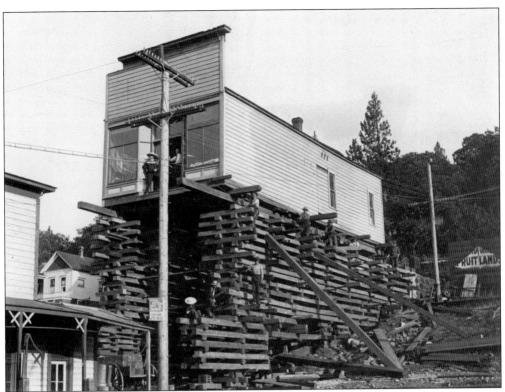

This building is believed to be the Eber Bradley Commercial Print Shop, which was located on Oak Street between Second and Third Streets but was later moved up to State Street and onto a stone foundation (made of rock from the same quarry as that used for the Riverside Church). One could buy a variety of items here, such as newspapers, books, and decorative prints that would help keep local residents updated on events and culture in other parts of the nation and the world.

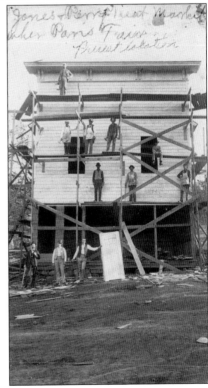

This picture, dating to the late 1880s or early 1890s, shows the construction of the Jones & Perry Meat Market (later know as the Hanna & Hartley Market). It was located where the Paris Fair Department Store would eventually open, on the southeast corner of Fourth and Oak Streets. Competition between meat markets was stiff, and quality service and good prices resulted in loyal customers. Daily trips to the meat market stopped by the 1920s and 1930s as more families acquired in-home refrigerators, known as iceboxes.

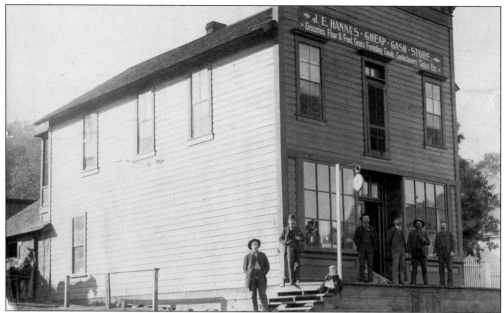

This 1891 image shows the J.E. Hanna Cheap Cash Store, on the southwest corner of First and Oak Streets. The sign on the front depicts the types of goods that early settlers would be able to purchase inside, including groceries, flour, feed, furnishing goods, confectionery, cigars, and more. The man on the far right, with no hat, is J.E. Hanna, who came to Hood River County in 1890. The woman standing at the far right by the fence is his wife, Margaret.

This image, dating to 1904 or 1905, shows the Davidson Building being built of concrete. After Horatio Foster Davidson lost his original wooden structure to fire, he refused to build either a new cold-storage building near the railroad or a fruit cannery in Hood River until the city organized a fire department. The city responded, organizing an effective fire department, and Davidson built his cannery of brick. He then opened this office space on the corner of Third and Cascade Streets, built entirely of concrete. The second floor was used as apartments.

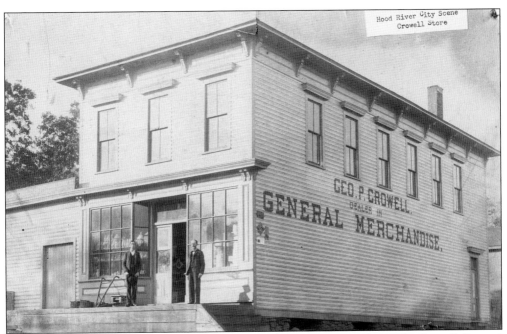

As the town continued to grow, so did the need for more goods and sundries. The Crowell General Merchandise Store, owned by George P. Crowell, was located on the southwest corner of Second and Oak Streets. Crowell bought the store in the mid-1890s from E.L. Smith and then sold it in 1902. Pictured in front of the store are Crowell (right) and his stepson Clarence English.

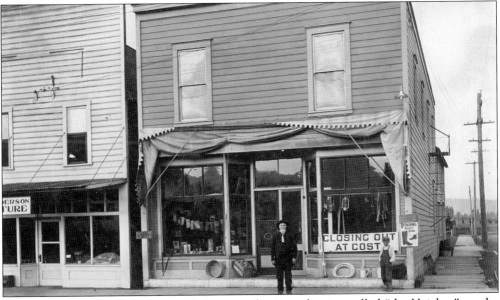

This is one of the earliest images of the upper business district, called "the Heights," on the southwest corner of Twelfth and Taylor Streets. Seen here in 1907 is the J.T. Holman Store. Unfortunately, for whatever reason, this store has fallen on hard times and, according to the sign, is "Closing Out at Cost." Holman's store was listed in a 1904 *Hood River Glacier* news article as a meat market, but that description does not match the type of items that appear to be offered for sale in this picture.

23

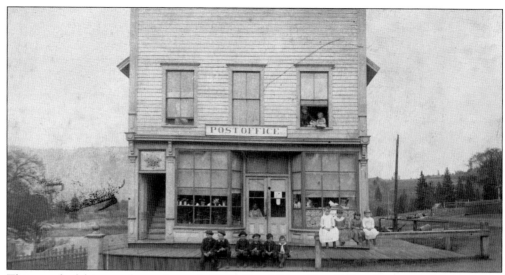

This wonderful image shows the early-1890s Hood River Post Office. It is unclear whether all these children are waiting for the daily mail delivery or are just posing for the picture. Whatever the reason, a trip to the post office would definitely generate some excitement back then, when family news came by postal mail. This building sat facing First Street on the corner of Oak Street, where the Yasui Japanese Market would later be built. Now that same corner is home to a modern Yasui Building. It is believed that Jennie Chaplin was the postmistress at the time of this photograph. The building housed an apartment upstairs, where one can see another small child with her mother at the window.

This 1910 image shows the Cottage Hospital, located at 714 Oak Street. Prior to the construction of this building, Hood River surgery patients had to travel by train to Portland or The Dalles. Drs. Howard Dumble, Frampton Brosius, Marion Watt, and J. Fred Shaw formed the Cottage Hospital Association in 1905. The facility could accommodate 12 to 16 patients and had its own nurses' training program, as well. In 1924, the state fire marshal declared the building unsafe and ordered it closed. This led to the formation and subsequent construction of the Hood River Hospital. The nurse sitting in the front is Zena Alice Craft, whose family donated the picture.

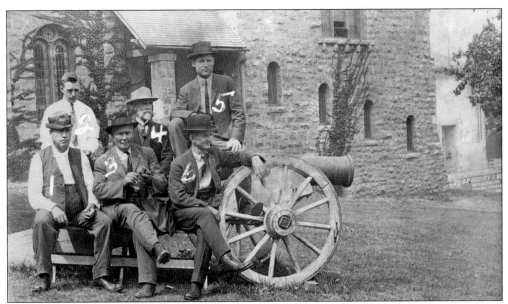

These men must have been very proud of this Civil War relic, featured in their official portrait, taken on the lawn between the present-day courthouse and the Riverside Church. These are the first elected county officials, chosen by the people in a 1910 vote. The first officers had been appointed by Gov. George Chamberlin when the county was set up in 1908. These men continued to be involved in many aspects of community service; it is uncertain what befell the cannon. (From the Max Moore Album Collection.)

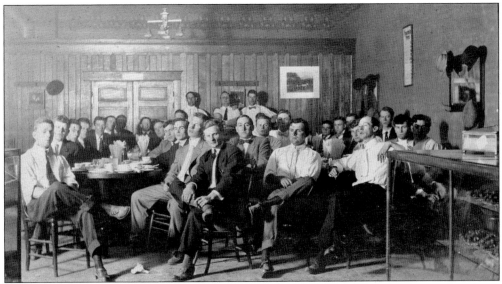

Pictured in 1910, this esteemed group of men met at Parkers Restaurant, later known as the Apple Blossom Café, and are noted as the Hood River Booster Club. This was the beginning of what is known today as the chamber of commerce. Imagine all they had to discuss as the community was growing by leaps and bounds. It is said that this group, becoming impatient with the slow progress of the Columbia River Highway from Mitchell Point Tunnel to Hood River, rounded up their teams and equipment and went to work bringing the highway to Oak Street themselves. (From the Max Moore Album Collection.)

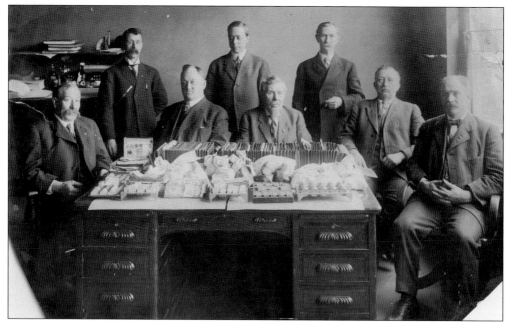

There are some serious men and serious money in this image of the First National Bank officers, most likely taken during an audit in 1911 or 1912. The men are, from left to right, (first row) D. McDonald, F.S. Stanley (president), J.W. Hinrichs, C. Dethman, and A.D. Moe; (second row) Copley Hinrichs (bookkeeper), E.O. Blanchar (cashier), and V.C. Brock (teller).

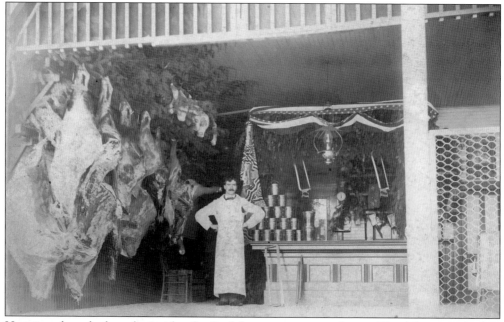

Here is a closer look at the inside of one of the many meat markets in Hood River in the late 1800s. Pictured is Henry McGuire, the butcher for Bonney's Meat Market. Because of the lack of refrigeration, animals were only processed and butchered as needed to keep them fresh and unspoiled. Still, it was a messy but necessary job. Notice the cans of lard stacked up on the front counter. This was an absolute staple in early American homes.

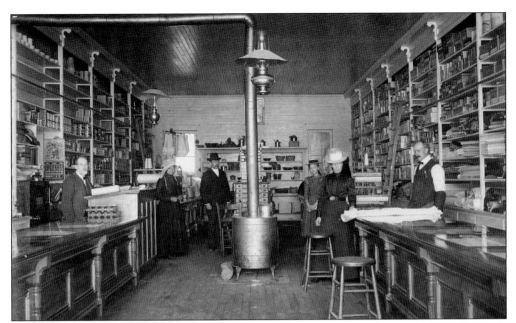

This interior shot of the Crowell Store shows a huge variety of items to meet the everyday needs of the community. Everything from fabric to household goods and books was sold by owner Mr. Crowell and his assistant, Clarence English. One can imagine the stories told around that central stove during the cold winter days. The calendar on the left is from the New York Life Insurance Company and is dated April 1901.

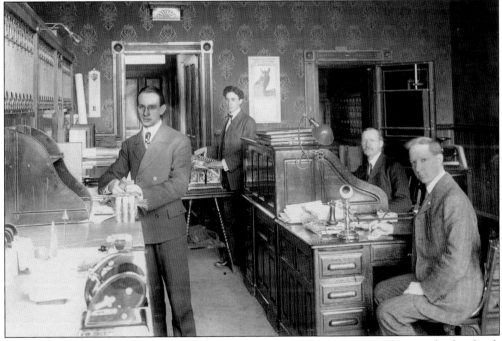

This is a rare look behind the teller's window at the Butler Bank in 1907. This was the first bank in Hood River. The man seated to the right is Truman Butler. Notice the candlestick phone and early check-writing equipment.

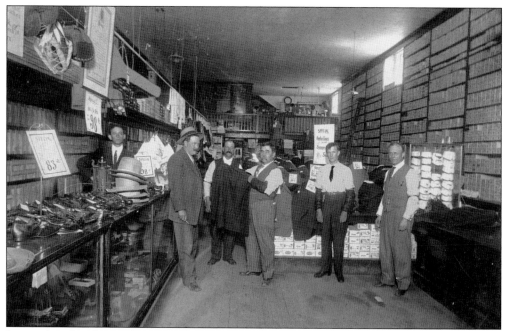

It must be a big day in the men's section of the Paris Fair Department Store, where someone is getting a new fitted suit. Notice the large number of shoes, hats, and shirt collars to choose from. The boxes stacked on the shelves would have held shirts, socks, ties, and gloves. To the left, shoes are priced at 83¢.

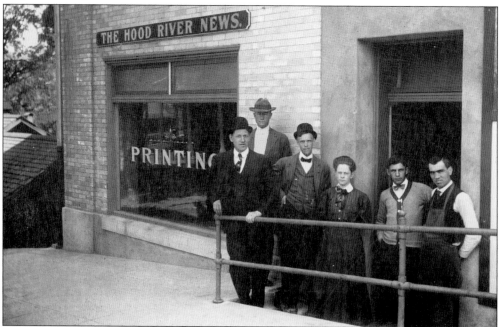

As the Hood River community continued to grow into the 1900s, the *Glacier* newspaper gave way to the *Hood River News*. This building, later known as the Franz Building, was located on the corner of Second and Oak Streets. This photograph of the staff in front of its offices was taken just five years after the newspaper was started in 1905.

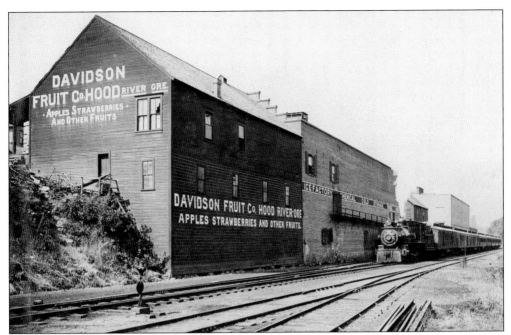

Fruit production put Hood River on the national map, thanks mostly to technical advances in cold storage and transportation. Quite often, cold-storage facilities had attached ice factories and cold-chemical facilities to help process the components necessary to get the fruit to market as freshly and quickly as possible.

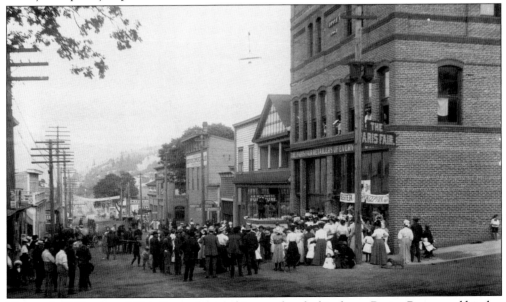

This early-1900s view of Oak Street shows a big crowd and a big day as Buster Brown and his dog Tige are in town for a visit in front of the Paris Fair building. Buster Brown was a comic-book character created in 1902 who later became the face of Buster Brown shoes. He was as close as kids got in that day and age to a superhero, even though parents considered him a bit saucy and mischievous. It is a sure thing that many kids in that crowd went home with new Buster Brown shoes that day.

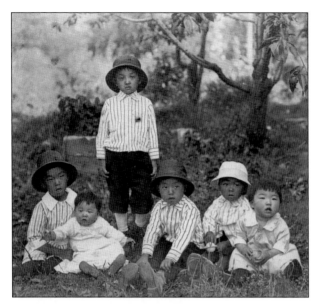

Japanese immigrants originally came to Oregon to work on the railroads, but by the early 1900s, Japanese American families were beginning to move to the Hood River valley to open businesses and start farms. By 1926, Japanese community halls were built in Dee, Parkdale, and Hood River as meeting places for current and new families to keep alive their Japanese culture while, at the same time, learning and adapting to their new American lifestyle. Pictured are, from left to right, Nob Hamada, an unidentified baby, Mam Nogi (standing), an unidentified child, Min Hamada, and Chiz Nogi Tamura.

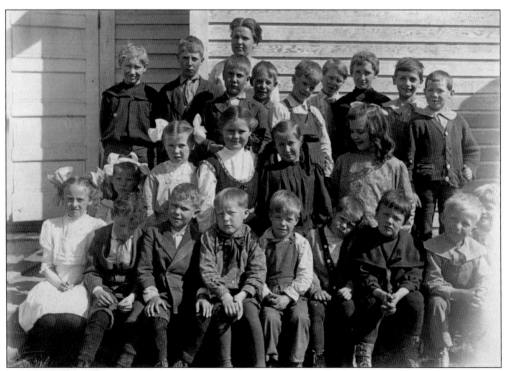

Finnish immigrants began to settle in the Hood River valley in the late 1890s, most of them in the Oak Grove area on the western side of the valley. Families like the Lingrens, Udeliuses, Edstroms, and Andresons soon created thriving communities of Finns that shared common ethnic and cultural backgrounds. With strong work ethics and love for the outdoors, sports, and large families, these people became a community that continues today, with members including the Hukari and Annala families, among others. Pictured here is the primary school class of Oak Grove in 1911.

In this picture, a mixture of ethnic backgrounds comes together for a fun day dressed up in Dutch costumes, complete with wooden shoes, at the Odell Grange Hall.

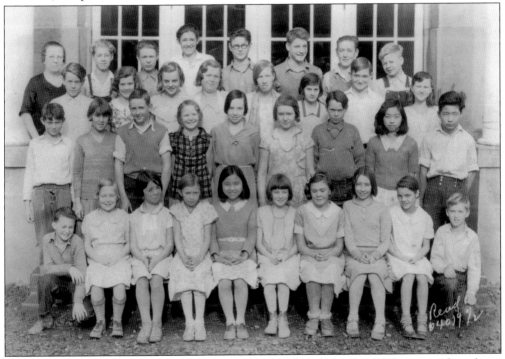

By the time of this class photograph, taken at Central Vale School in 1933, it is evident that a huge variety of cultures and ethnic backgrounds were represented in the communities surrounding Hood River. Schools had grown past the one-room format and were now dividing into grades. This picture was taken during the Great Depression, when families living on farms like those in the Hood River valley worked hard and depended on friends and neighbors to help keep them going through this difficult time.

Leaving the east to come west did not necessarily mean the early pioneers left behind their desire for knowledge and reading. As early as 1896, Hood River had a library club that allowed friends to share and trade books by setting up lending libraries inside established businesses. The fee to borrow a book was 2¢ a day. By 1911, the Hood River Women's Club began work in earnest to build a permanent library. After the receipt of an Andrew Carnegie Library Foundation grant, construction began in 1913. While still in its original location at 502 State Street, the library has undergone several major renovations to allow it to continue serving the needs of Hood River County residents.

The last image in this chapter is of the Hood River Pioneer Society at a reunion meeting in May 1953. The History Museum owes its beginning to the Pioneer Society, which in 1907 established a long-term vision of collecting and preserving important artifacts, documents, and photographs that would someday be displayed and preserved in a museum. The History Museum continues this dream and continues to display artifacts from the original Pioneer Collection among its current exhibits.

Two

SPRING

TIME AWAKENING

The snow had lingered over time
But the west wind began to blow
And just that quickly it vanished;
Wind magic made it go.
Old mother earth looked quite forlorn
So tawdry and unclean
Till all the edges of her skirts
Showed a spreading fringe of green.

—Sallie A. Carson
excerpt from "Spring Is Just Around the Corner"

Spring is a welcome sight in Hood River after a long, cold winter. Typically, it arrives in all its glory around the middle of April, heralded by the opening of the blossoms on the fruit trees. For over 100 years, visitors have come by various methods of transportation to gaze in awe at the blanket of pink and white flowers covering the valley. These blossoms will eventually become sun-kissed apples and pears as the summer months arrive. Spring also signals the beginning of the recreation season, as windsurfers, kiteboarders, kayakers, and mountain bike enthusiasts arrive from across America and around the world to enjoy all that the Columbia River Gorge has to offer.

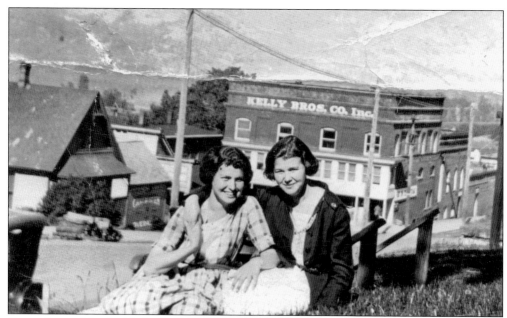

Spring brings Martha Neileigh Hjaltalin (right) and a friend out in the sunshine to sit on the courthouse lawn in 1918. The sign for Kelly Bros. Co. is visible in the background. Kelly Brothers, owned by brothers Fielding and Roy Kelly, was primarily a fruit-exporting business. However, they had several other business ventures around town as well, including a feed store and a furniture store. The store in this picture, on Fifth and State Streets, was a hardware store.

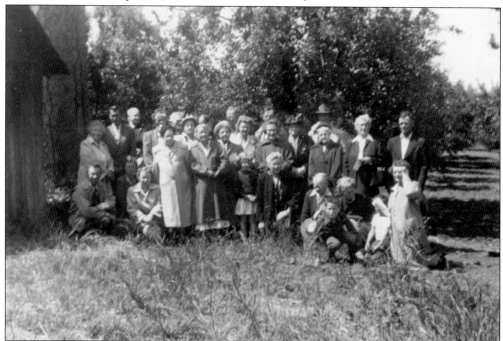

Seen here is a 1952 group picnic outing of the Hood River County Historical Society. This would have been just a few years before the group turned over the Pioneer Collection to the county and began to work towards opening a museum.

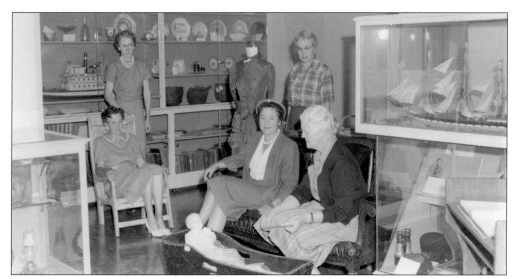

This image, published in the *Hood River News* on June 19, 1958, is from the opening of the first Hood River County Museum location, in the basement of the courthouse. This was not just the museum opening; it was also a celebration of Hood River County's golden anniversary. Shown in this picture are, from left to right, (first row) Louise Birkenfeld, Genevieve Collie and Sarah Moller; (second row) Hazel Bonebrake and Ellen Blanchar. The artifacts displayed on the shelves are still part of the museum collection today.

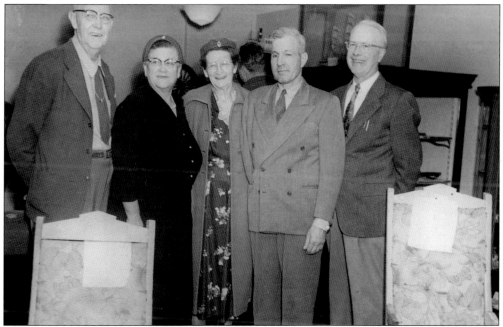

This photograph is also from that 1958 museum opening. According to the caption in the news article, these individuals were largely responsible for the formation of the Hood River County Historical Society and the museum. They are, from left to right, E.E. Lage, Ina Moore, Nora Rumbaugh, Joe Horn, and Mace Baldwin. Lage, Moore, and Horn were original members of the Hood River Pioneer Society. What an exciting day this would have been after years of hard work and dedication to preserve the story of Hood River County.

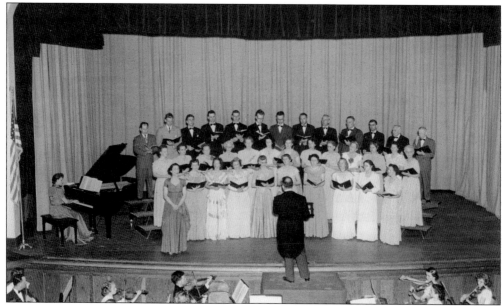

Hood River County is rich in both beauty and culture. Music has always been a part of the lives of community members. A turning point in the development of the Hood River Music Association was the hiring of Boris Shirpo as director of the fledgling organization. Maestro Shirpo worked to develop music expertise among the children of the county. Many of these young people went on to have major roles in larger music organizations, such as the Portland Chamber Orchestra. This 1948 image shows an adult choir and the children's orchestra, with soloist Kathryn Oaks.

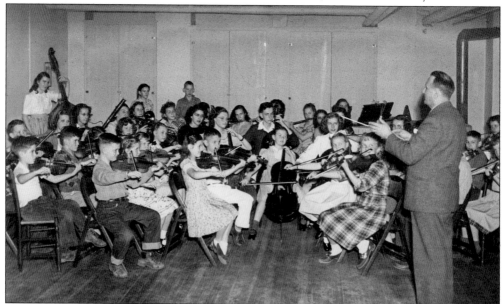

This is a rare image of a rehearsal for the Mid-Columbia Sinfonetta, directed by Boris Shirpo. Kathryn Oaks once said of the opportunity to sing with this group, "it was quite a change from the blasé union musicians who had been in the orchestras which accompanied me before this and the young orchestra, some of whom could barely touch the floor to tap their toes, gave my skepticism pause and a really great accompaniment."

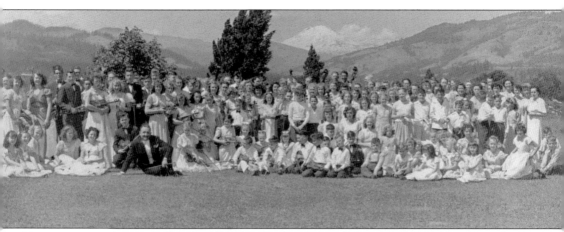

The notation on this image identifies the group as the combined chorus and orchestra, gathered at the site where the Hood River Music Festival is to be held (with Mount Adams in the background). The photograph was taken by Ray Webber and may have been for a publicity packet to promote the event. Boris Shirpo is seated on the ground to the left, wearing a tuxedo. This is most likely from 1948, the year of the first Hood River Summer Music Festival. Others would step in after Maestro Shirpo to continue the tradition of music in Hood River County, which is still strong today.

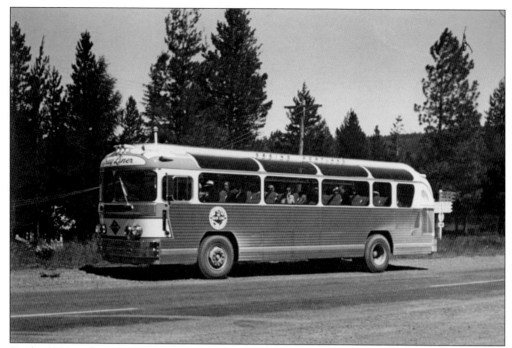

By the 1950s, when this image was taken, entire busloads of people were coming to Hood River each spring to tour the Loop Highway (Highway 35) and see the apple and pear blossoms from the comfort of their seats on the Gray Line. The Fruit Loop, as it is known today, still brings thousands of visitors each spring to the valley, where the ground is covered with so many blossoms that it looks like snow.

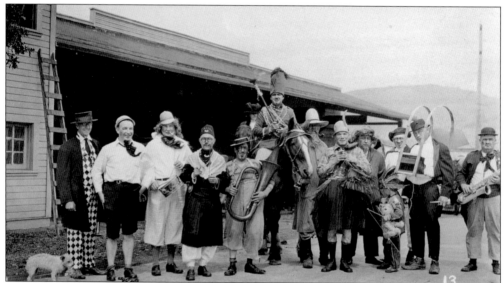

The exact story behind the 1930s Pet Parades is not known, but the museum has quite a few interesting images from the event, including this one of an apparent band. Members include, from left to right, Walter Walters, N.C. Coulter, C.C. Anderson, Chas Dyer, Hal Nesbit, Rod McRae, Ed Lage, Ed Steel, John McLean, Harold Hershner, E.C. Smith, and John Young. The little guy in the front is unidentified, but it looks like he is having fun.

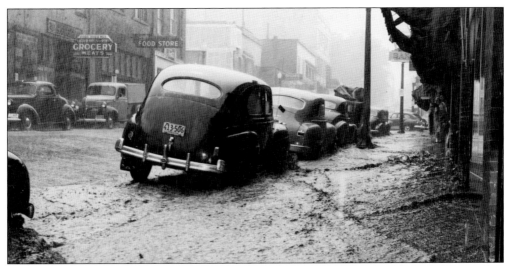

This spring image looks more like a scene from November than from June 7, 1947. This is Oak Street, between Second and Third. The notation on the back of the photograph says, "rain and hail storm ruining pear and cherry crop for us," providing a reminder of how quickly an entire year of fruit production can be ruined in a moment of unexpected weather. (Courtesy of Ray Webber.)

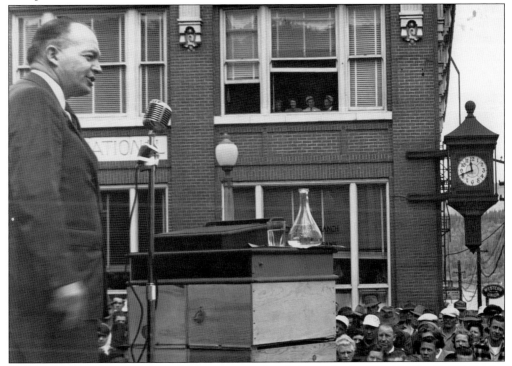

This image was taken at one of the many war bond drives during World War II. While the speaker's name and the exact date are unknown, it is clearly 11:40 a.m. Notice the unique podium supported on top of a stack of fruit boxes. It appears that the young man in the upper window is wearing an Army uniform and tie. Hood River received national recognition for selling over $1 million in war stamps. Over the course of the war, 85 million Americans purchased bonds, totaling approximately $185.7 billion. (Courtesy Archie Radliff.)

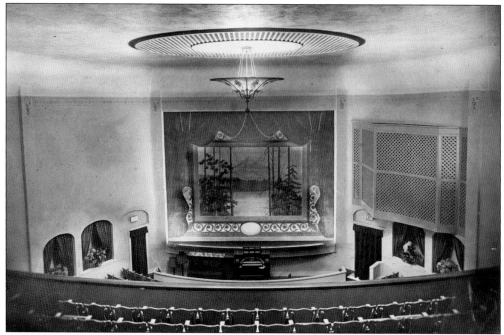

Arthur Kolstad had a love of Hood River and a love of theater. He and his wife, Vera, came to Hood River County in 1913 and opened two theaters. This was the silent-movie era, and the Wurlitzer organ in the Rialto Theater, pictured here, was played by Vera. The original organ is now under restoration by the History Museum in preparation for display as a primary artifact at some point in the future.

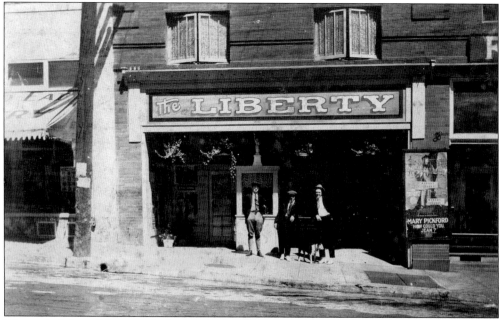

This is the Liberty Theater, which was located at 308 Oak Street. In this image, the Mary Pickford movie *How Could You, Jean?*, which hit the big screen in June 1918, is being advertised. Movies were an important social opportunity in a small rural community like Hood River.

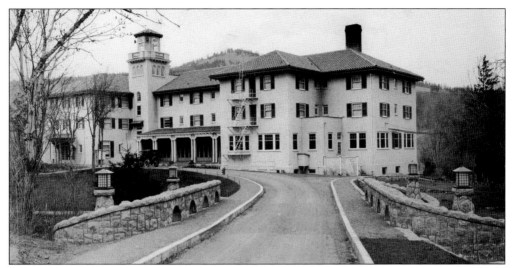

The Columbia Gorge Hotel was constructed on the site of the former Wah Gwin Gwin Hotel, which was built by Bobby Rand in 1904. The location is a beautiful site for any hotel, positioned at the head of a tumbling 208-foot waterfall. Many famous people have stayed at the Columbia Gorge Hotel, including Pres. Theodore Roosevelt, Myrna Loy, and Rudolph Valentino. Although the hotel went through some tough times during the Great Depression, even becoming a retirement home, it still stands today as a unique and opulent lodging opportunity overlooking the Columbia River.

In this image, one can almost hear the 1920s music spilling out of this entrance door to the Columbia Gorge Hotel. Imagine the well-dressed guests stepping out of this car and making their way into the grand lobby and eventually to their beautiful rooms. During the days of steamers along the Columbia River, the riverboat captain would signal the hotel by one whistle for each passenger about to disembark to allow the maids to turn down the appropriate number of beds. (Courtesy of Ruth Buche Allen.)

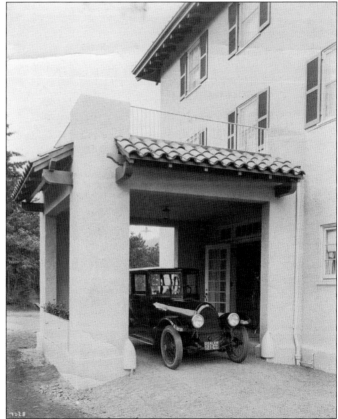

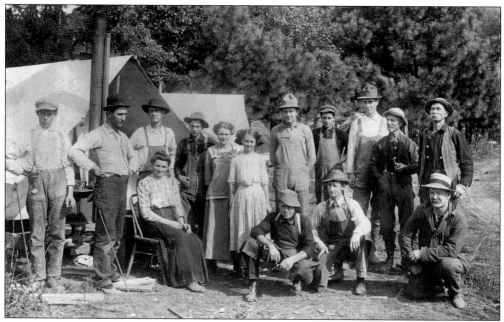

Spring brings milder weather, allowing workers to get back to the forests, fields, orchards, and farms. This image shows working families at the Max Welton Orchard in 1918. In this day and age, entire families were involved in all aspects of work, with everyone doing his or her part to get the job done and provide for the family.

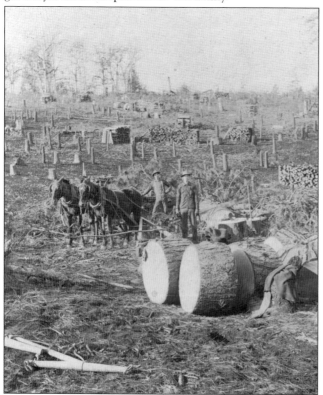

This picture gives a much deeper understanding of the term "stump farm," which was used to describe land that had the larger trees and timber removed but still needed to have the stumps taken out before it could be turned into productive orchard or farmland. A good team of workhorses would have been a valuable asset for this process. At least there was plenty of firewood for the winter.

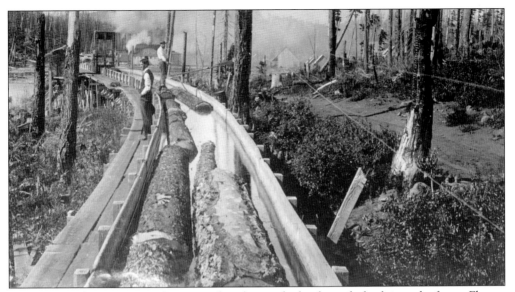

Higher up in the mountains, the spring thaw brings the lumberjacks back into the forest. Flumes were built to assist in getting the cut logs down the mountain to the mills. This 1916 image shows logs on their way to the Green Point Mill at Parkertown, owned by Frank Davenport. Many a legend tells of workers from the woods riding logs down these flumes to the mills at the end of a day's work.

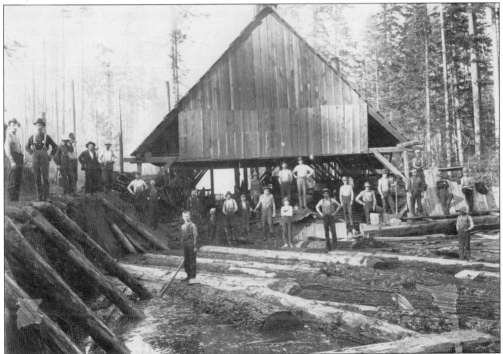

This very early mill image, taken in 1902, shows a variety of ages among the workers, including the young boys out on the logs in the millpond. This is noted as being the McCourtney Mill, owned by Frank Davenport, who came to Hood River with his wife and family in 1890. He had his hand in the operations of several of the early logging operations and mills.

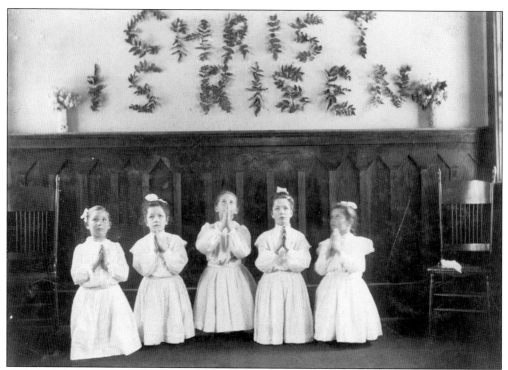

Spring also brings holiday gatherings and events, such as these young girls in their Easter program at the Riverside Church about 1905. They are, from left to right, Ethel Triebar, Ellen McDonald, Florence Brosius, Ethel McDonald, and Amy Stockwall. Imagine how special they felt all dressed in their matching white dresses for this very special event, with all their friends and family watching from the congregation.

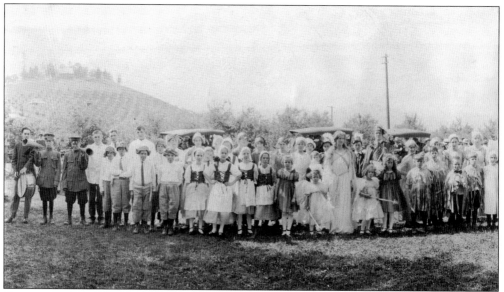

County music supervisor Aldine Bartmess (Small) put together this nature pageant at the Pine Grove School in 1915. The program appears to have involved costumed groups from various ethnic backgrounds; a drummer; a goddess; and some fairies, complete with their magic wands.

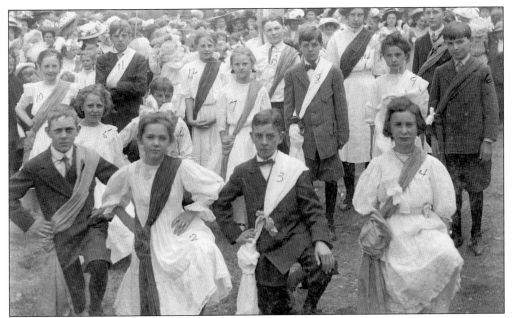

It would not be spring without a maypole dance. This one was taught by Professor Biggs in 1908. He came from Portland to hold such classes for several summers. The students are, from left to right, (first row) Earl Koberg (1), Francis Castner (2), Glenn Hunt (3), and Adrienne Epping (4); (second row) Wilma Thompson (5), Harold Ingalls (6), Elda Jackson (7), Buss Yowell (8), Betty Epping (9), and Joe Williams (16); (third row) Katherine Baker (10), Malcolm Button (11), Susanne Hoye (12), Basil Williams (13), Mildred Huxley (14), and Fred Cashow (15). In the background, it appears that a huge crowd was waiting in anticipation of this event.

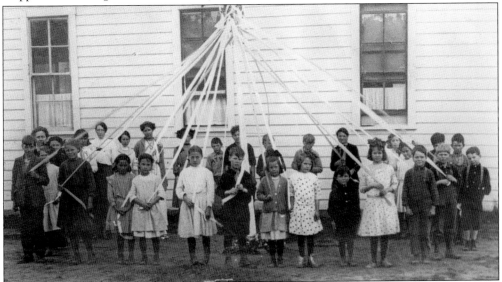

This 1913 image shows another maypole dance in Mount Hood, this one held at the Old Cooper School. A notation identifies the teachers as Hattie Bailey and Ella Everson Sheldrake. Hopefully, if all goes well, the pole will be wrapped in a beautiful woven pattern at the end of this dance. This style of maypole dance originated in 18th-century Europe and undoubtedly was a spring tradition brought to Hood River by the many Finnish and German immigrants.

This early image shows the Henry Coe residence, just west of downtown on Sherman Street. Strawberry fields surrounded the home and were a vital source of revenue until the fledgling apple trees would mature and begin to produce fruit. The most common strawberry at that time was the Clark Seedling.

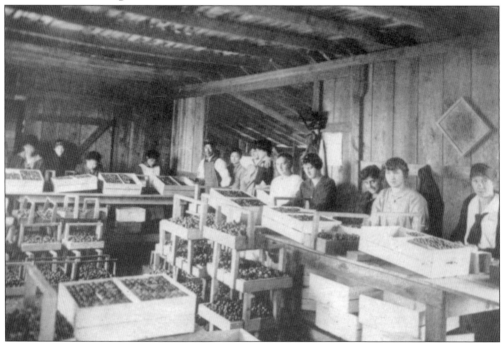

Strawberry production went into full swing after train transportation came to Hood River. This allowed the soft, sweet berries to reach the Portland markets fresh from the fields. Among the packers in this photograph are Kate Forry Bruce (third from the right) and Louise Forry Gordon (far right).

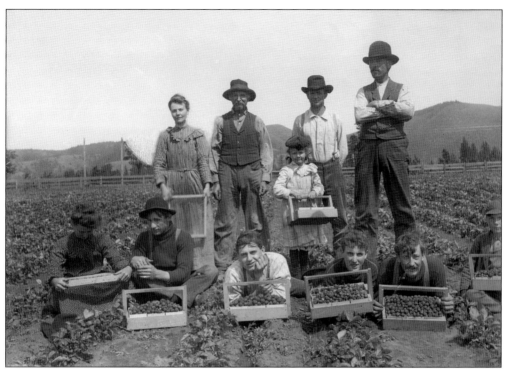

Here is a lighthearted look at an early multigenerational group of strawberry pickers. There might even have been some friendly competition going on between teams to see how quickly they could fill the six hallocks that comprised one wooden carrier. This family outing surely resulted in some strawberry jam.

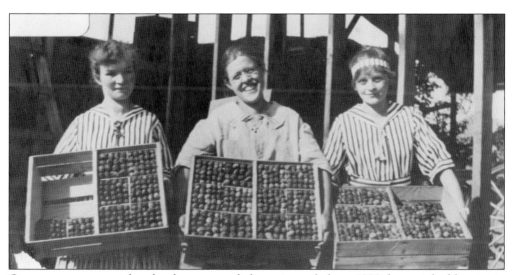

On a more commercial scale, these young ladies, pictured about 1920, have picked berries in preparation for packing. On the left is Edna Plog Hart, with Lola Graff Gall (center) and Olga Plog Hague (right). It appears that Lola might be the fastest picker of the three, judging by the number of berries in her crate.

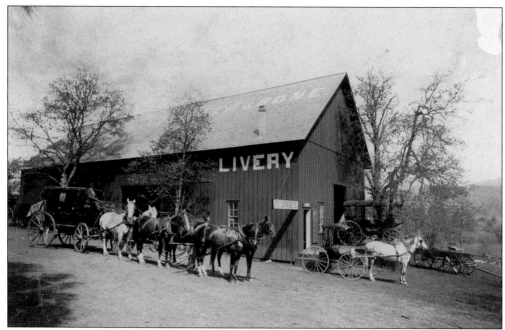

Dated 1892, this photograph shows a more deluxe mode of travel for the time. The livery barn was located on the corner of Cascade Avenue and Second Street and was owned by Charles R. Bone and E.S. Olinger. Stagecoaches connected residents to the Oregon-Washington Navigation Company trains and served the entire valley. (Photograph by Frank Neff, courtesy of Bert Stranahan.)

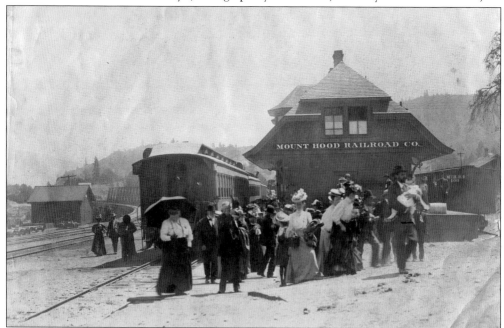

Imagine the excitement of an opportunity to board the train in Hood River and travel near and far. There is no notation on this undated image to indicate the event for which all these people have dressed so elegantly. Perhaps they are welcoming relatives visiting from the east, but whatever the occasion, hats and finery seem to be the attire of the day.

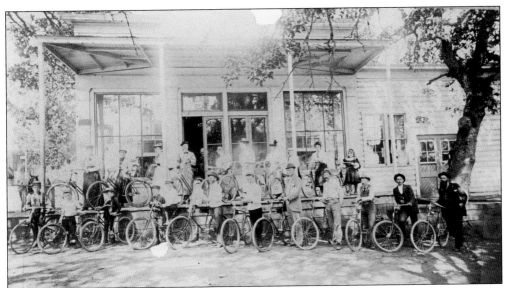

Bicycling as a form of exercise and sport is not just a pastime of modern residents of Hood River County. This image shows men and women, young and old, preparing to leave for a bicycle party. Names listed on the back include familiar early residents, such as Blowers, Bartmess, Nicholson, Brosious, and Harrison. The picture is believed to have been taken in front of the A.S. Blowers Store on the northwest corner of Third and Oak Streets.

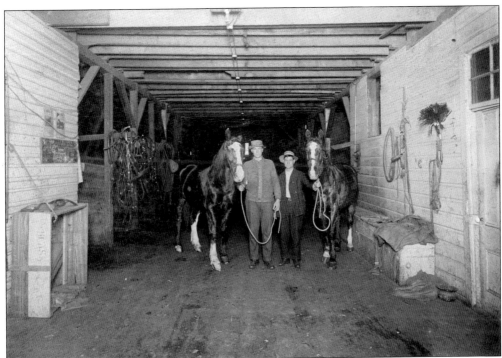

This is a rare look at the interior of one of the many livery stables in Hood River. These two fine-looking horses are sure to be in capable hands. A notation on the back of the image notes one of the men as M.B. Campbell.

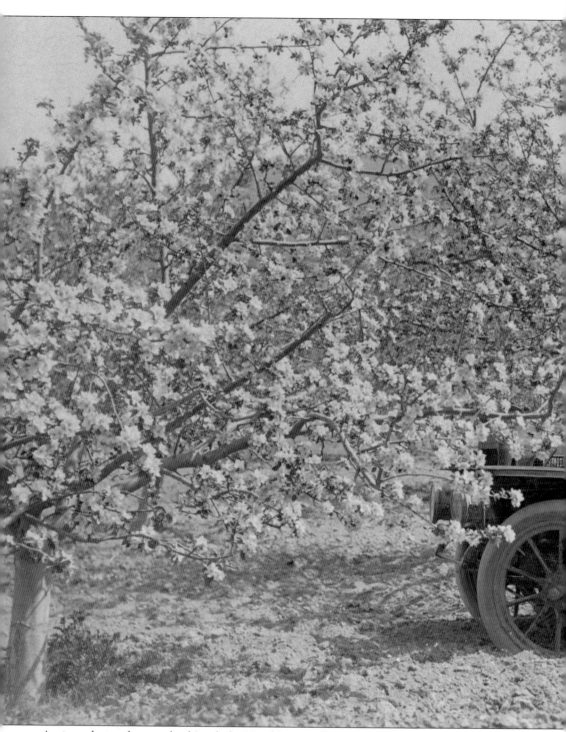

At times during the month of April, the Hood River Valley appears to be blanketed in snow as the apple and pear blossoms burst open in all their stunning beauty, each blossom representing the hint of a bountiful fruit harvest in the fall. This family is unidentified, but the gentleman is sure to be very proud of his car. The vehicle is believed to be a 1908–1909 White Touring steam-powered

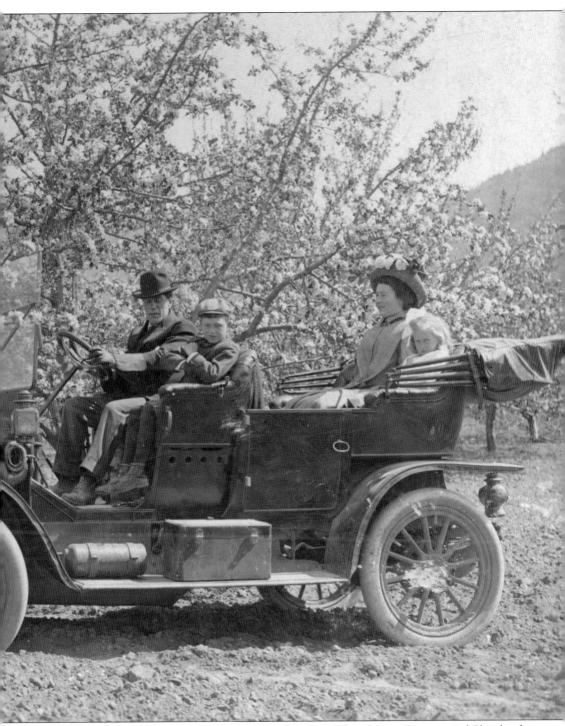

automobile, with a 20-30–horsepower engine, built by the White Motor Company of Cleveland, Ohio. All White steamers were right-hand drive. Since there were very few paved roads in the valley at the time, this magnificent machine was most likely brought to the gorge by ship.

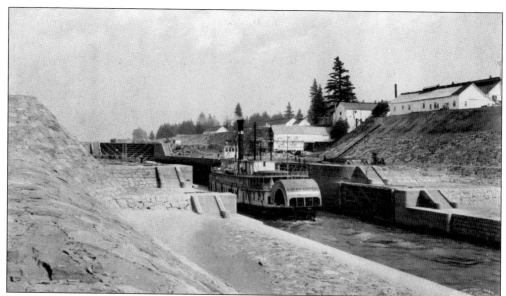

Part of the process to tame the mighty Columbia River and make it accessible for shipping and transportation involved the installation of a series of locks. This early image shows the stern-wheeler ship the *Bailey Gatzert* navigating the lock system. Cascade Locks is about 20 miles west of the city of Hood River. (From the Thompson Album.)

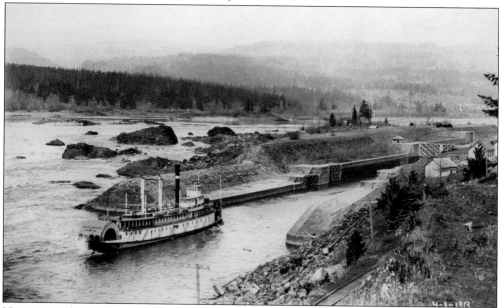

Here is another view of the *Bailey Gatzert* making a west approach to the locks. Congress authorized the construction of a canal and locks at the Cascade Rapids in 1876. The charge was to support open-river navigation on the Columbia between Portland and the agricultural lands of eastern Oregon and Washington. The US Army Corps of Engineers began work on the project in 1878, but difficult working conditions, changing engineering plans, and erratic congressional appropriations delayed the opening of the canal and locks until November 1896. When completed, the canal measured 90 feet in width and 3,000 feet in length. The locks had a lift of 42 feet and cost $3.8 million to construct.

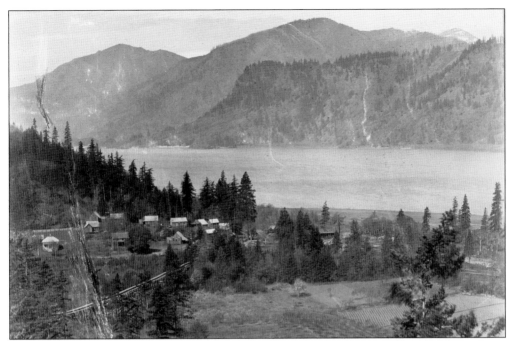

All along the Mid-Columbia River, small settlements sprang up. This early-1900s image shows the small community of Ruthton, which included a mill. Note the wooden flume coming in from the hills, which would bring logs that had been cut in the forests above Hood River. The picture notes the "old Morton Place" farm in the foreground. (Donated by Emory Davenport.)

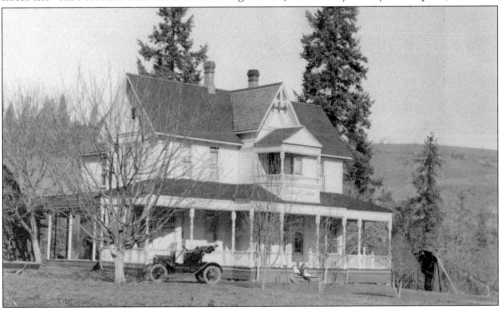

Pictured here is the Barton Tucker home, which was built in 1892 at the Tucker Bridge in Hood River. The car in front belongs to Dr. Howard L. Dumble, who is at this home attending to the birth of Tucker granddaughter Marie Tucker Dreske. The little girl on the front steps with her dolls is Blanche Tucker Kure, another granddaughter of B.R. Tucker. Spring brings new life to the Hood River orchards, as well as to the families that inhabit the Hood River valley.

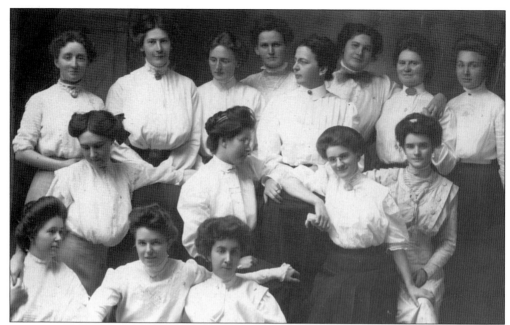

Living in the Hood River valley was not all work. This group of women, pictured in 1910, was known as the J.A.G. Club. Their pose is rather unorthodox, and it is unclear whether their casual stance was intentional or whether the photographer captured them unaware. A few of the names are noted on the back, including Sturgess, Walton, Hartley, Woodworth, Davidson, Andrews, Claxton, Hartwig, Johnson, Allen, and Orr.

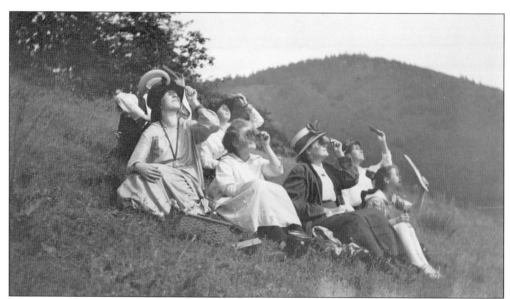

With their picnic lunch packed in the basket and their viewing cards made, this group headed to the hills above Hood River for a rare opportunity to watch a partial solar eclipse on June 8, 1918, very close to 3:00 p.m. This party had approximately 28 seconds to enjoy the totality of the event. (From the Davidson Family Collection.)

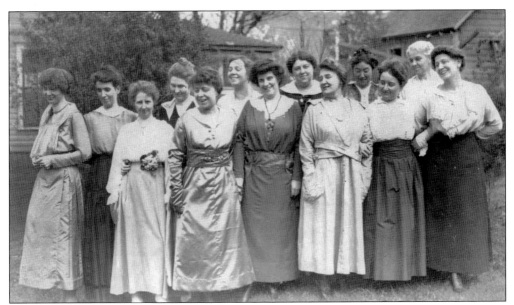

Whist is a four-person card game that was very popular in the late 1800s and early 1900s. This image shows the Hood River Whist Club in 1912. It is a sure thing that the many hours of fun and companionship that accompanied these card games helped ease the stresses and loneliness of living on the frontier of Oregon.

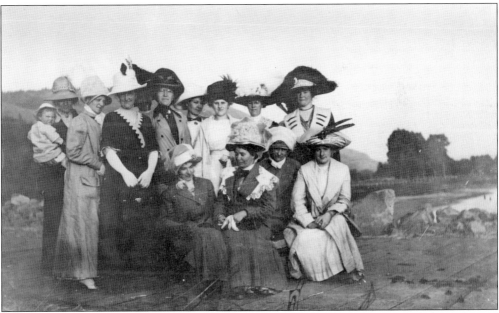

The stylish ladies on this early postcard image are identified as members of the Hood River Women's Club, 1912–1913. Their hats, dresses, and coats provide great examples of the fashions of the day. One might wonder if the woman on the far left was unable to get a babysitter for the day, as she is the only one that has brought a child along for the outing.

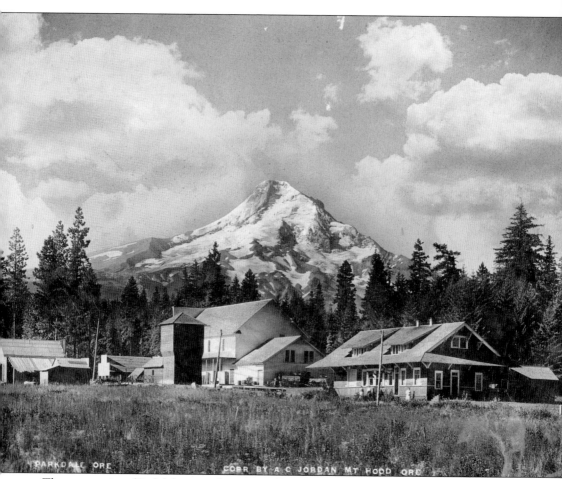

PARKDALE ORE COPR BY A C JORDAN MT HOOD ORE

The community of Parkdale sits in the upper valley, at the base of Mount Hood. R.J. McIsaac arrived in the valley from Iowa in 1902 and, by 1910, had plans for a store to serve the growing population of orchardists. Many early orchardists in this area were Princeton graduates; these inexperienced men were called "New Yorkers." Today, Parkdale is the southern terminus of the Mount Hood Railroad and is a small but bustling community still serving the needs of orchard families.

Three

SUMMER

TIME ETERNAL

Down the cool, shady path to the babbling brook,
Where we love to go to peruse our book;
Where you can stretch, refresh and relax
From a day of heat and over-tax.

—Charles Harvey Beltz
excerpt from "The Cool, Shady Path"

A cool, shady path would be a great thing to find on a hot summer day in Hood River. Maybe it is located just off the Historic Columbia Gorge Highway and leads to a magnificent waterfall, or maybe its part of the Barlow Trail that brought so many settlers in and through the mountains of Oregon in the late 1800s. Either way, the path is sure to include tall, stately fir trees and soft, moss-covered rocks along cold, rambling creeks. For some, summer mornings are spent skiing on the slopes of Mount Hood, with afternoons and evenings devoted to sailing on the mighty Columbia River. Others find their summer evenings consumed with exploring local breweries, wineries, art galleries, and inviting local farms. Summer offers something for everyone before making way for the golden hues of autumn and harvest time.

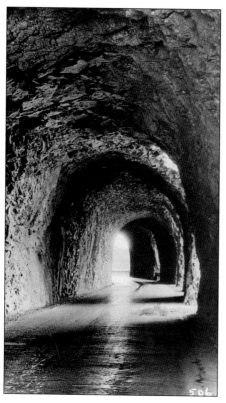

The Historic Columbia Gorge Highway, designed by Samuel Lancaster, was constructed between 1913 and 1922, with the Mosier Tunnels being located east of Hood River. The area represented in this image covers approximately five miles that pass through two climate zones. In the 1960s, as the modern Interstate 84 opened, the historic highway was forgotten, and the tunnels were filled in with rock. In the 1990s, interest was regenerated in this classic route. Lost sections of the highway were located and unearthed, and the highway between Hood River and Mosier now serves as a much-used and much-loved bicycle path.

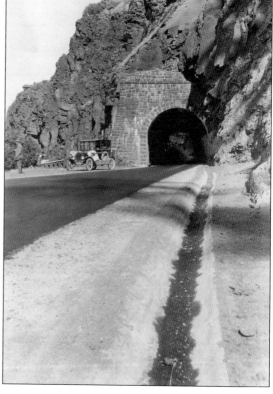

This man is most likely stopping to take in the massive Columbia River view that is prevalent all along the Historic Columbia Gorge Highway. This is the easternmost tunnel towards the community of Mosier, which sits in Wasco County to the east of Hood River County. The rockwork walkway visible to the left of the tunnel still exists today.

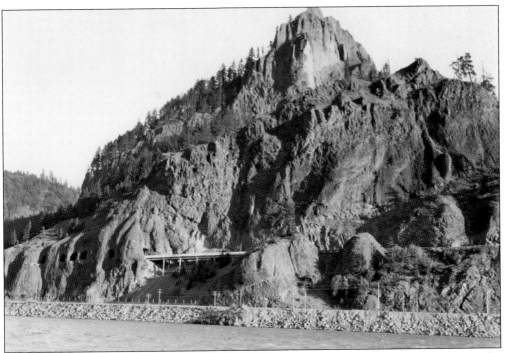

This view shows the Columbia Gorge Highway as it moves through Mitchell Point. Note the windows carved in the north-facing side to allow travelers glimpses of the beautiful scenery. This tunnel system was destroyed in 1966 when the interstate was widened. The Oregon Department of Transportation is developing plans to eventually recreate this tunnel, connecting another portion of this historical highway.

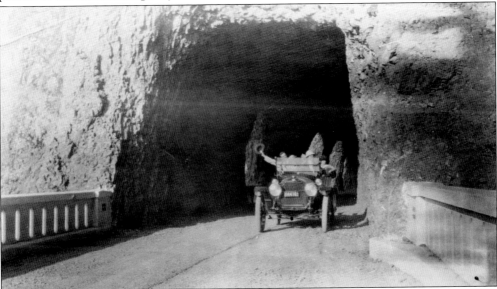

This image shows the interior of the Mitchell Point Tunnels. Imagine driving around these tight curves and corners in a Model A automobile. Designed by engineer John Arthur Eliot, the tunnels, like all the Columbia Gorge Highway, are intended to blend stone construction with the surrounding environment for a truly scenic driving experience.

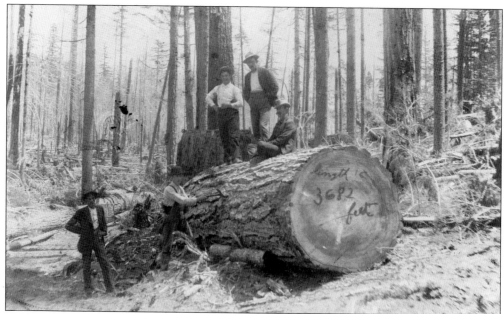

Working in the woods and taking out logs was a rough and dangerous job. This 1901 image shows Jim West (far left), A.J. Shepler (center), Ike West (sitting), and two other unidentified men with a huge felled tree. The notation written on the end of the log would refer to 3,682 feet of board that could be produced from this one log. The back of this photograph notes that it was taken shortly after Shepler had recovered from typhoid fever and pneumonia, both diseases that were common and deadly at the turn of the century.

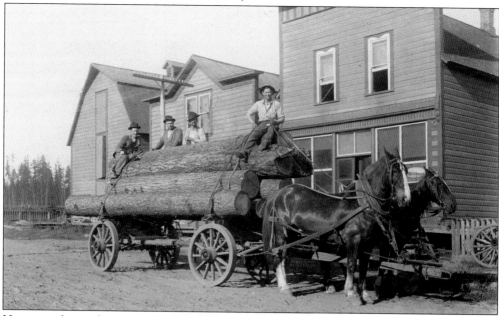

Horses, mules, and oxen were invaluable commodities in the early timber industry. This 1911 picture was taken by Joe Hess in front of the Bill Helmer store. The men are identified as, from left to right, James Dimmick, Joe Demmon, Bill Helmer, and Roy Blagg. The building to the left is an icehouse.

If this very large tree were harvested for logs, loggers would most likely have had to use springboards. Many times, the bases of trees this large had knotty burls that made them difficult to saw through. Divots would be cut in the tree several feet off the ground. A springboard would then be put in the divots, and the loggers would stand on either side, using a two-person crosscut saw to bring down the tree. The springboard elevated them above the thicker circumference at the base of the tree. In the forests around Hood River, stumps with springboard divots can still be found.

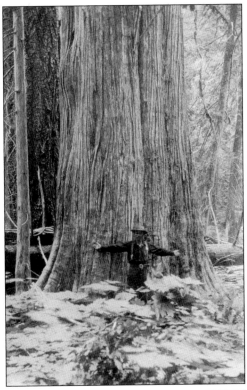

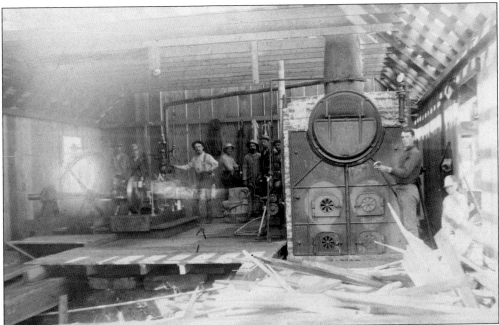

This image shows the boiler at the Parkertown Mill around 1890. The mill is described as being near Green Point, where the Kingsley Reservoir is now located. The boiler would need to be fed wood continually—surely a hot and sweaty job—in order to generate steam power for the mill. The arrow drawn on the photograph points to John E. Binns.

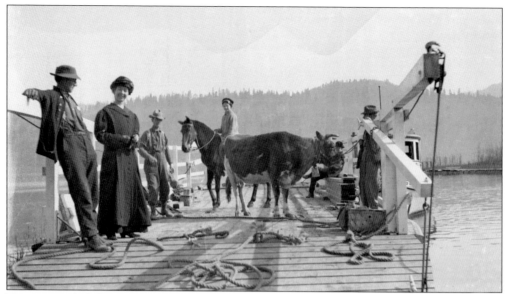

Ferries provided the only means for crossing the Columbia River from the mid-1800s until the Oregon-Washington Bridge was built in 1924. This photograph shows the ferry being used to transport a horse and rider, several people, and a fine-looking milk cow. There was a story passed down of one man who would take his cow across the Columbia River to Bingen every morning for her to graze while he went to work. Every evening, the cow would be patiently waiting for him to come so they could travel back across the river. Maybe this is that cow, or maybe this man just purchased her in Hood River and is taking her home to Washington. Either way, the ferry was the only way to make the trip during this era. (From the Davidson Family Collection.)

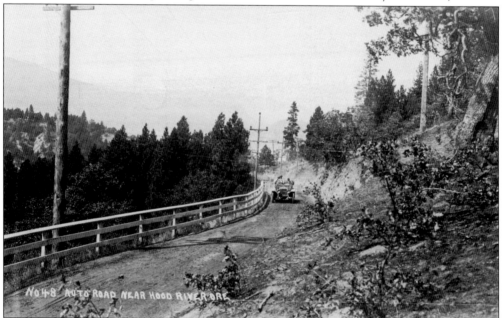

This 1918 postcard image shows the Eastside Road, which was the early precursor to Highway 35. Traveling up this road must have been an adventure, but it was necessary to connect Pine Grove, Odell, and Parkdale to Hood River and the outside world.

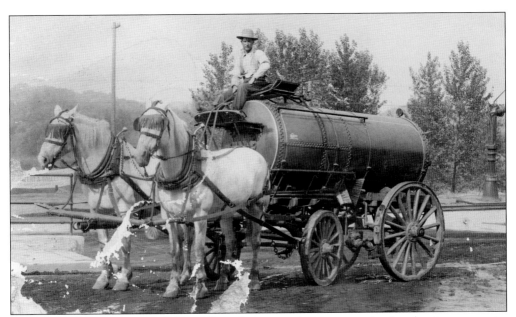

With all the horse travel on early Hood River County roads, it is no wonder that the city community needed a street cleaning wagon. With this beautiful team of matched white horses and this shiny new street cleaner, this unidentified man would be busy keeping the streets clear and clean.

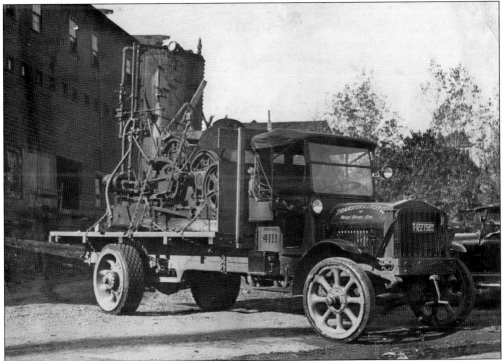

This 1923 photograph, by Fred Donnerberg, shows a truck that was driven by Donald Mowers. The location of the image is the industrial triangle bounded by the train tracks, Front Street, and State Street. It appears that, on this particular day, the livery truck is being used to transport a steam donkey engine, presumably for use at a logging site.

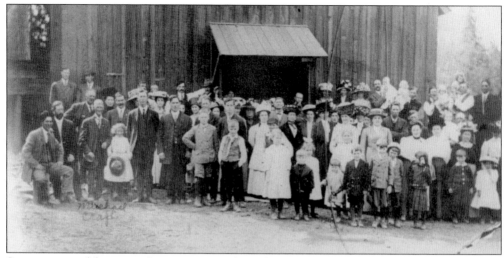

Summertime celebrations often center on Independence Day events. This 1911 photograph shows what is quite possibly the entire community of Mount Hood at the Fourth of July picnic at the old community hall.

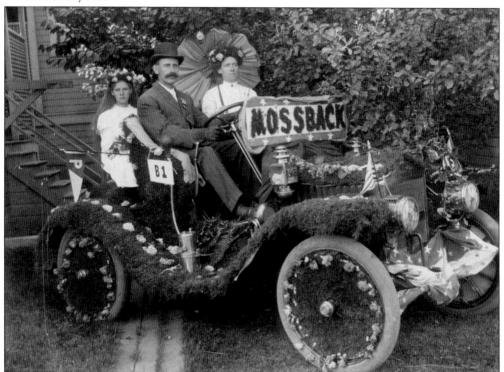

This photograph includes Howard Frary, his wife (Maud Tucker Frary), and their niece showing off their automobile, which was decorated for a 1918 car show. The word "mossback" dates back to the mid-1800s and meant someone with old-fashioned and conservative ideas. Later, it was used to describe early Oregon pioneers. It was even used to describe a large old fish that has survived long enough in the waters of Oregon rivers to gather moss on its back. Whether this photograph represents a political statement or just a good-natured jab at the Oregon climate, it was sure to have raised a few eyebrows.

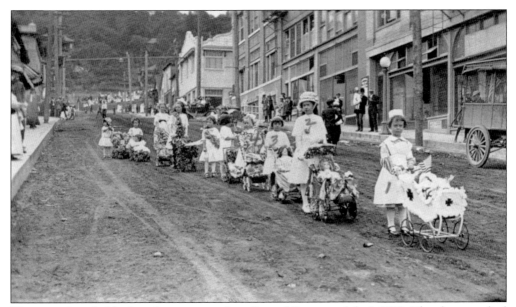

These unidentified little girls are pictured on Second Street on July 4, 1913. They have readied their dolls and buggies for a parade in honor of the nation's birthday.

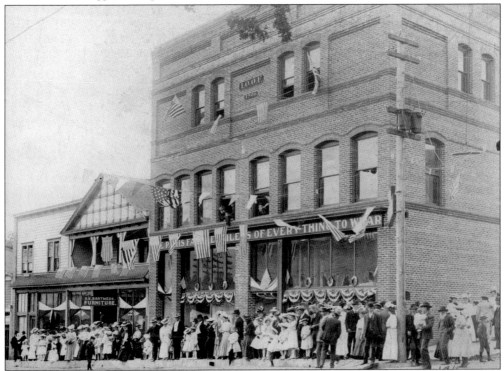

This Fourth of July celebration in 1911 was held in front of the Paris Fair store, located at 315 Oak Street. The crowd appears to be waiting for the parade to begin. Next to the Paris Fair is the S.E. Bartmess Furniture Store, which also sold caskets made from packing crates (the first example of recycling in Hood River). The top floor of the Paris Fair building housed the Independent Order of Odd Fellows (IOOF) fraternal organization. Imagine the view from the second and third floors.

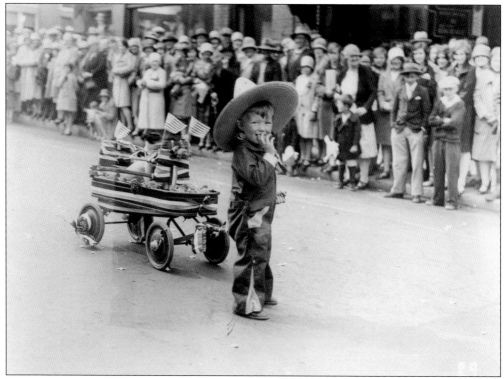

This little guy, identified as Roger Thomas, has entered his pup in the 1930s Pet Parade. Quite a crowd has gathered to cheer him on. (From the Kent Shoemaker Collection.)

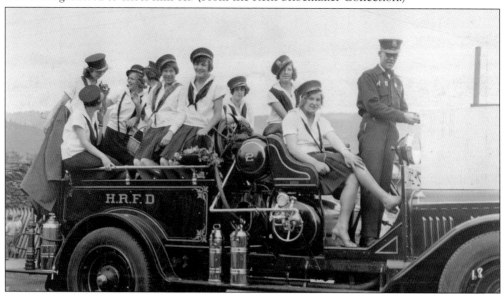

A summertime parade is just not complete without a fire truck and pretty young ladies. This is Hood River Fire Department's Engine No. 2. Fire Engines No. 1 and No. 2 were housed in the new combined city hall and fire station on Second Street, where the current municipal court is located. This engine can now be seen at the Western Antique Aeroplane & Automobile Museum in Hood River.

This Fourth of July image was taken in the 1950s, judging by the cars in the background. The name of the Native American man is unknown, but what is known is that this photograph was taken by Dick Radliff in the field behind what was then the Hood River High School. This is the area that is now the Hood River Pool and the new Hood River Fire Hall.

This delightful image shows four young Japanese American girls in a true American patriotic tribute. They are, from left to right, Seiko, Mutchan, and Tomiko Kusachi and Aki Imai Nakamura. (From the Imai Family Photo Collection.)

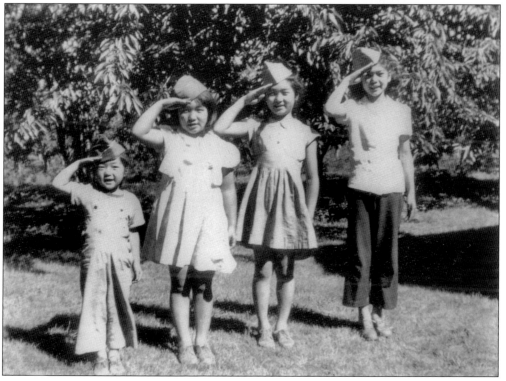

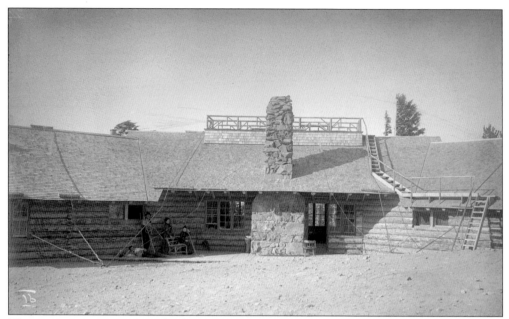

This rustic structure is the Cloud Cap Inn. Built in 1889, it was designed to serve as lodging for those whose adventurous spirits took them to the base of Mount Hood for climbing and exploration. It operated during the summer months until 1925. During World War II, it served as a private residence. In 1954, the local mountain rescue unit, the Crag Rats, saved Cloud Cap from demolition by the US Forest Service. Years later, in 1974, the amazing building was placed in the National Register of Historic Places. (From the Anna Lang Collection.)

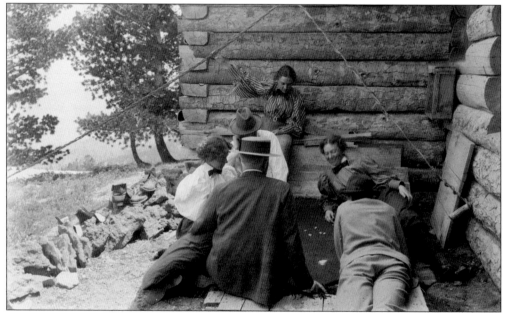

After a day of hiking, this group relaxes outside Cloud Cap Inn to play a game of dice. Note the wonderful rough-hewn log construction of the building, which has remained intact even to this day.

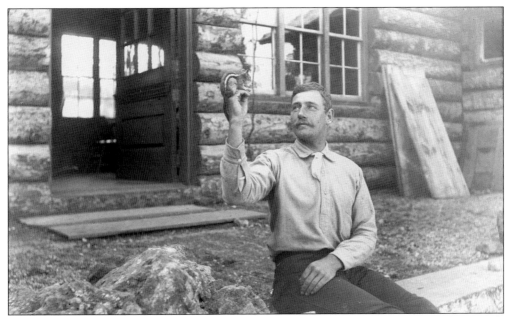

Will Lang is pictured just outside the front door of the Cloud Cap Inn. Will appears to have made friends with one of the many little creatures that live in the forest around the inn. The chipmunk's name, according to the notation, is Jerry. Note the front door, which is now on display at the History Museum to showcase the history of mountain sports. Will and his brother Harold served as guides for Mount Hood climbers for many years until Will left Oregon for the Klondike Gold Rush in 1897. Later tapped by Gifford Pinchot to help develop Alaskan forest management, he is credited as being the "Father of Alaskan Forestry."

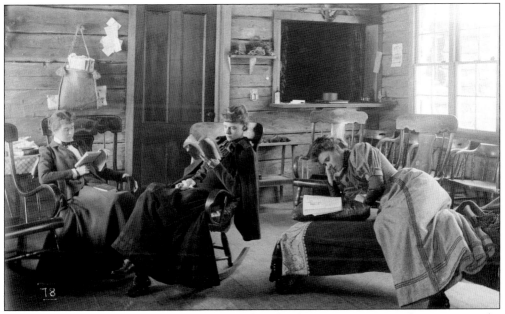

This rare look inside the living room area of the Cloud Cap Inn captures what appears to be a relaxing summer day of friends and reading. Pictured are Louisa Eaton (left), Elizabeth Lang (center), and Anna Lang.

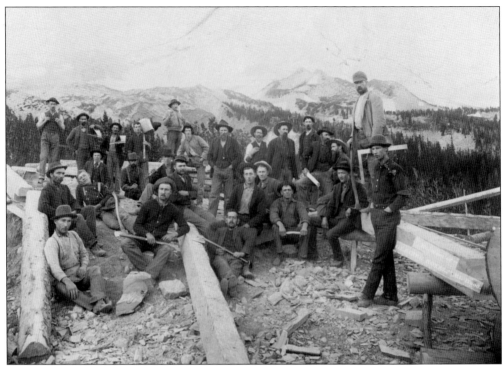

This is the crew that worked through 1888 and 1889 to construct Cloud Cap Inn in its remote location far above the Hood River valley. The foreman is distinguishable by the simple page plan that he holds; everyone else carries some type of cutting or shaping tool. Names listed on the back are Henry and Lewis Tomlinson; Jim, Will, and Bert Langille; John Hilstrom; Jack Lucky; Link Evens; Marvin Rand; and George and Bert Stranahan. The inn was built entirely from trees harvested from the slopes surrounding its location. Cloud Cap Inn is managed by the US Forest Service today, and tours are available during the summer months.

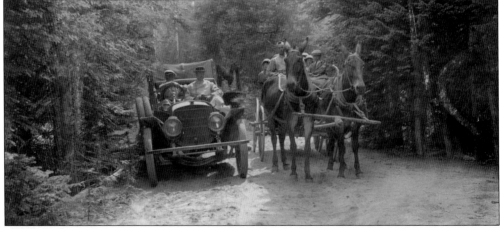

The roads through the county forests were rough and difficult no matter the mode of transportation. This image, from around 1911, is believed to show the turnaround point where one had to trade the luxury of automobile travel for a mule wagon. These people are unidentified, but it has been speculated that the man in the passenger seat of the automobile might be a wealthy visitor, as he appears to have a personal driver. Note that he is carrying a cup of coffee for his journey.

It is uncertain what this man is pointing out to these hikers; it could be the glaciers of Mount Hood or the majesty of Lost Lake. Whatever it is, this group will certainly have a memorable outdoor experience as it hikes over the rustic trails of the Mount Hood forest. Note the heavy climbing ropes the men are carrying as well as the full-dress attire on the women.

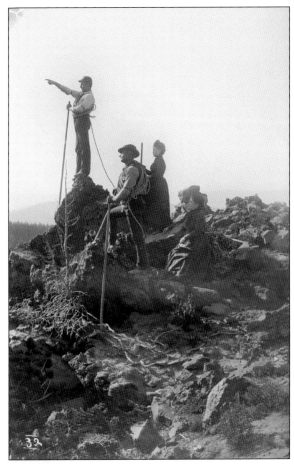

This group is posed outside of Cloud Cap Inn as it prepares for a day of climbing. Note the climbing staffs as well as the face paint on the man in the middle.

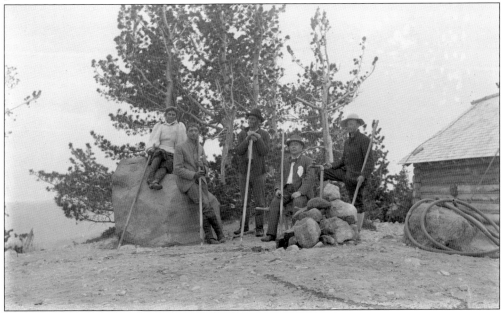

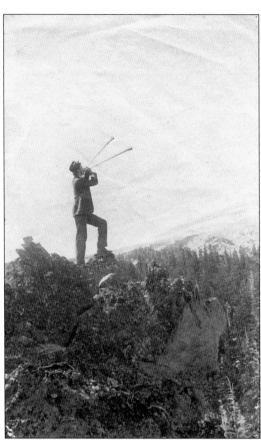

The alpine horn signaled the call to breakfast at the Cloud Cap Inn. This picture was taken in the late summer of 1889.

This pre-automobile, pre-1889 photograph was taken on the north side of Cloud Cap Inn. Even in the relative comfort of the wagon, it would have been a long, dusty, bumpy ride up to the inn. With that many men in the wagon, the last steep climb close to the top would have definitely required four strong horses.

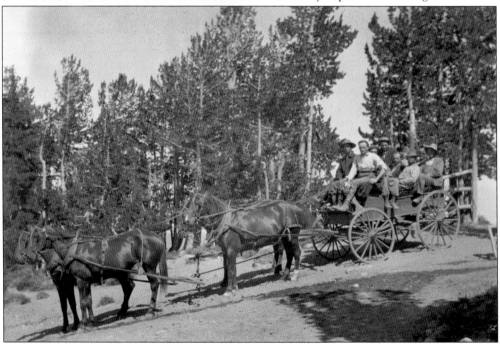

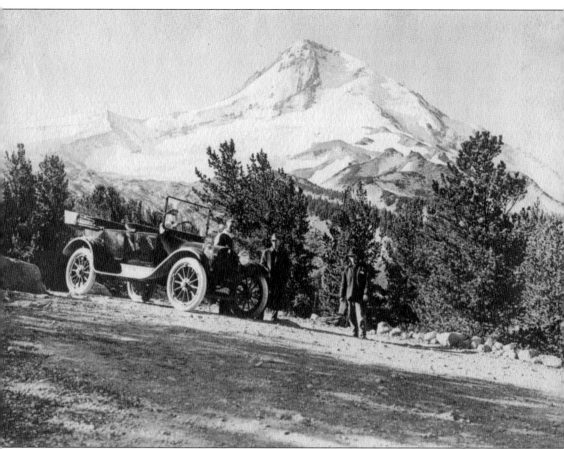

This photograph, dated 1916, shows what is believed to be the first car to make it to Cloud Cap Inn on its own power. This Dodge may very well have had to go up the last incline in reverse to have enough power. The men standing are identified as, from left to right, Harry and Joe Thomson and W.E. DeWitt. The driver's name is unknown. The rock on the far left is known as the "6,000 rock," indicating its elevation. It is still there today. In 2008, during a 3,200-acre forest fire on the northeast side of Mount Hood, a heroic effort by firefighters, an air tanker, and orange fire repellent saved this historic structure from being lost. The Cloud Cap Inn is the second oldest building in the country that is maintained by the US Forest Service.

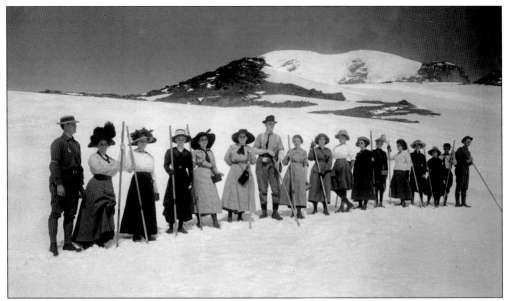

This photograph shows a very early group of mountain climbers, believed to be on Mount Adams directly across the river from Hood River and Mount Hood. The men in this group are most surely guides. Judging by their big picture hats and fashionable skirts, some of these ladies appear to be more appropriately dressed to visit a fancy resort than to climb a mountain. Some records have noted that the ladies wore the big skirts to assist with the "call of nature," since there were scant private locations to be used for that purpose.

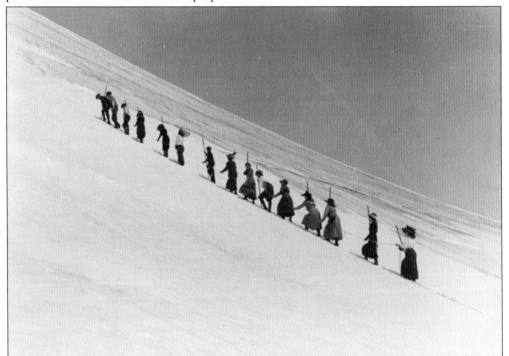

Here is the same group of ladies as they climb up the side of the glacier. Hopefully, their stays and corsets were not too tight to allow them to breathe the thin air at this elevation.

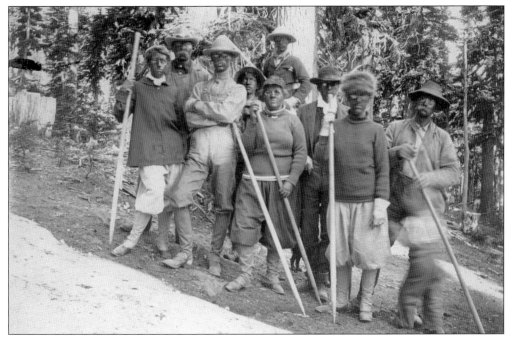

This climbing picture is from a few years later, dated July 30, 1904. Max Moore stands to the far right, and the man in the rear is the guide for the trip. Max recalls that the group is holding alpine stalks and that they have their faces greased with Vaseline and charcoal to protect them from the reflection of the sun on the snow, which could cause facial blisters. (From the Max Moore Album Collection.)

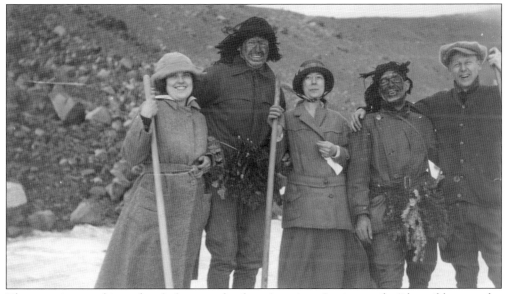

The notation on this undated photograph of an American Legion reads, "the wild men, who were tamed, however, by the frigid atmosphere of the mountain." It is not known if this is before the climb or after, but the group seems very pleased with the excursion. The American Legion climbs started in 1921 and ended in 1944. During this time, over 3,000 people signed on for this once-in-a-lifetime adventure.

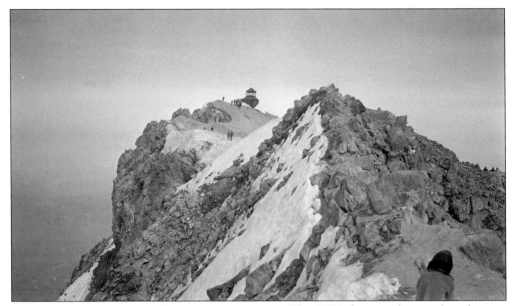

This 1926 photograph was taken the year the Crag Rats organization was established. Looking up from the Sunshine Route on the north side of the mountain, it shows the lookout cabin at the summit. The Crag Rats are the oldest mountain search-and-rescue organization in the United States and are still going strong today. They are identified by their signature black-and-white-checked shirts. (From the Alva Day Collection.)

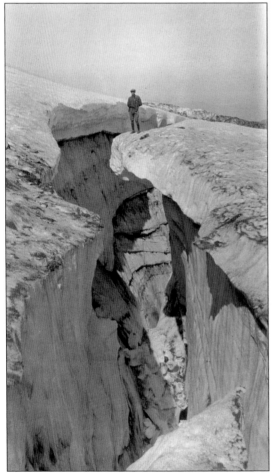

This image shows some of the difficult and dangerous terrain of Mount Hood. While this image was most likely taken in the 1920s or 1930s, the crevasses of the Eliot Glacier are becoming increasingly shallow each year because of rising global temperatures. Eliot Glacier is the largest glacier by volume on Mount Hood, at 73,000 acre-feet, and has been measured by ice radar as having a depth of 361 feet.

This image of Crag Rat members leading a group shows the steepness of the Sunshine Route on the north side of Mount Hood.

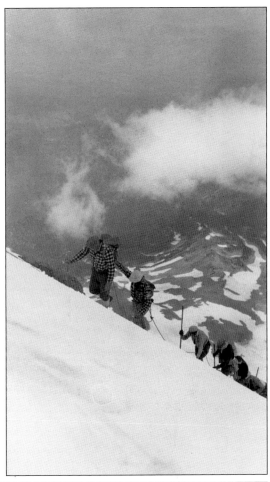

Mountain expert Bill Pattison dates this image to the early 1930s. It shows a Crag Rat summit climb with the lookout cabin in the background. The name "Crag Rat" came about after a mountain rescue of a lost boy on Mount Hood. When a reporter asked the group for its name, the men remembered a nickname their wives had always given them, saying they were like rats climbing over the mountain crags. The name stuck and, to this day, is synonymous with this dedicated and knowledgeable group.

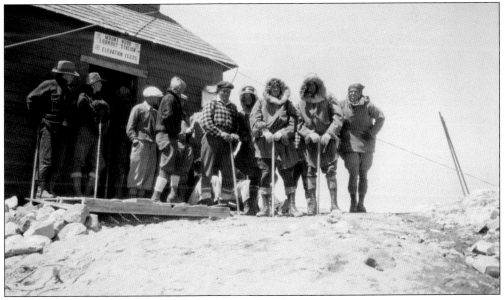

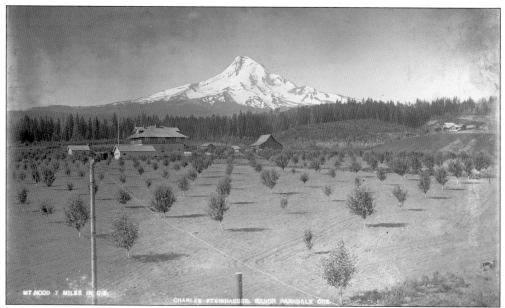

This picture shows a very early image of a young orchard in the Parkdale area, seven miles from Hood River. Just imagine the wonderful apples that will be harvested from these trees in a few years. The notation on the bottom indicates that this is the Charles Steinhauser ranch.

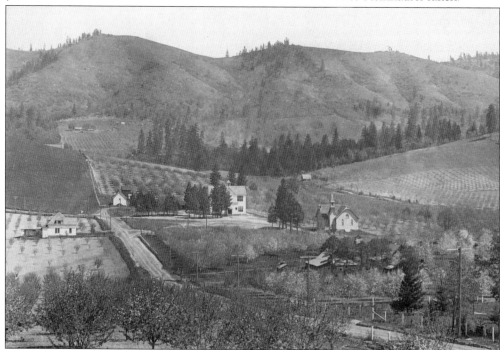

This 1915 image shows the early community of Pine Grove. It identifies the Coffin ranch, along with Pine Grove School (center) and Pinegrove Methodist Church (right), which was established in 1907. The school closed in 2011, and the students were sent to other facilities. The church still stands, now used for weddings and special events. The orchards are still there, but instead of apples, they now produce pears.

This image, from a stereoscope view, shows another early image of Pine Grove, taken from the east. The building in the center of the view is the grange, which was later moved to the other side of the road.

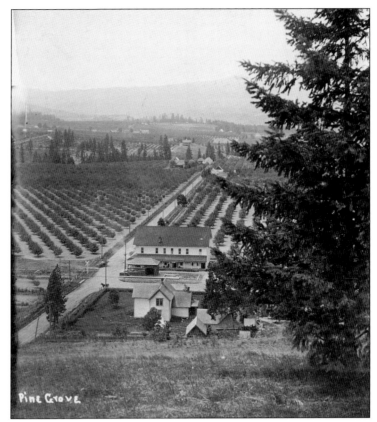

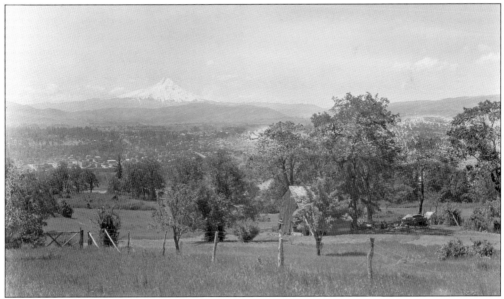

This is a much later view of the valley. The orchard trees are bigger, and the town has grown. Maybe the abandoned farm on the right was left behind by some early settlers. With Mount Hood in the background and the orchards in the foreground, this image has become synonymous with Hood River.

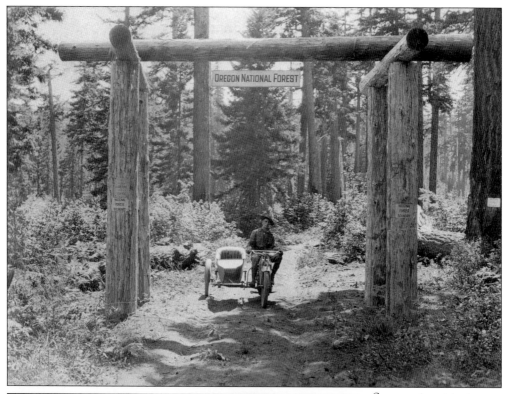

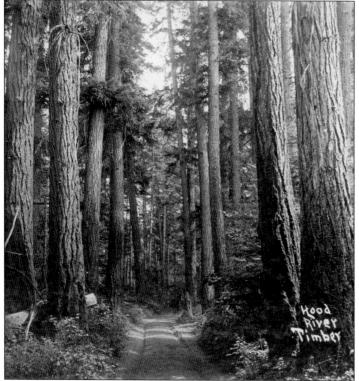

Summer is not just about mountain climbing. It also brings people into the area forests for hiking and biking. This photograph of Joe Thomison was taken by Fred W. Donnerberg at the entrance to the Mount Hood National Forest, located about 8 or 10 miles south of Parkdale.

This stereoscope view simply says "Hood River Timber" and shows an early dirt road through the tall Douglas fir timber of the forest. This would be a great place for a cool summer walk.

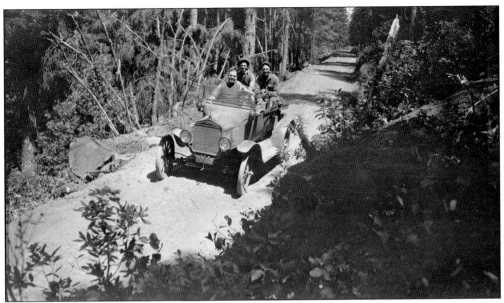

Down a dusty forest road in Hood River, these three men seem to be excited for whatever the day may hold. Maybe they are on their way to Cloud Cap Inn or Tilly Jane Campground. The driver is missing and may very well be the person who climbed up the road bank to take this photograph.

While the present Cooper Spur and Cloud Cap Roads offer an easy grade for modern automobiles, the original road climbed in a nearly direct line from the Valley Crest area, up China Hill, past the Mount Hood Lodge and the Goldsburg Ranch, through the Elk Beds, then up Ghost Ridge to the inn. This long, continuous climb must have been a killer for horses pulling heavily loaded coaches or wagons. All in all, a total of approximately 6,000 feet of elevation had to be gained in the approximately 30 miles between the train depot at Hood River and the inn at the top of Ghost Ridge. The Mount Hood Lodge, shown in this image, would have been a crucial stop on this journey.

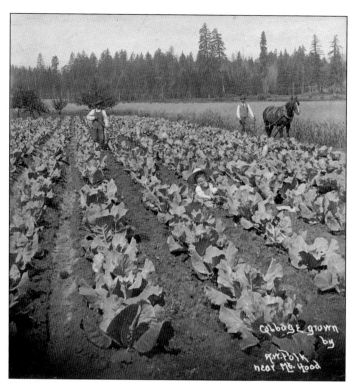

Some early farmers supplemented their fruit crops with row crops while they waited for the newly planted trees to yield. The field of cabbage seen in this stereoscope view is noted as being near Mount Hood.

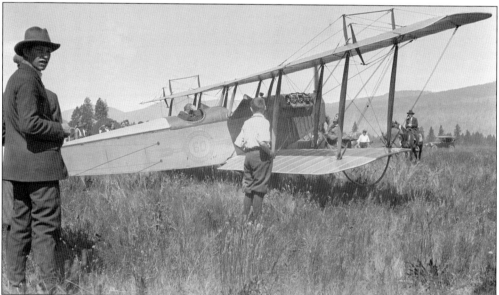

This image shows three very different styles of early transportation: horse, automobile, and airplane. The logo on the side of the plane identifies this Curtiss Jenny as part of the Oregon, Washington & Idaho (OWI) Airplane Company, which was founded in 1919. A May 1920 issue of *The Dalles Chronicle* mentions that rides in these planes cost $10, a significant amount for that time. Most pilots for this company were retired fighter pilots from World War I. This image is believed to show Victor Vernon (in the back seat), chief pilot for the OWI Airplane Company. (From the Alva Day Collection.)

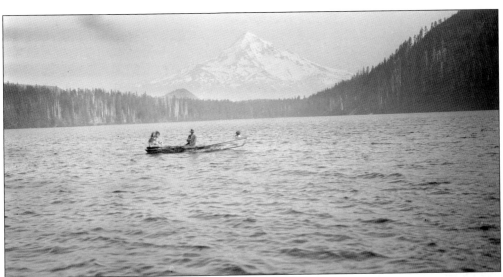

Lost Lake and its iconic view of Mount Hood have been drawing outdoor enthusiasts for over 100 years. The indigenous people of this area undoubtedly availed themselves of the abundance of fresh fish and huckleberries in the area. The first recorded visit by white settlers was in 1873, when John Divers and Peter Neal guided a group of seven men to the shores of "Big Lake." Then, in 1880, Ezra Smith and Milton Odell guided a group of 11 men in an attempt to find the lake. After a day and a half, the party arrived at the desired location only to discover that the lake was lost. The name Lost Lake has stuck to this day. (Photograph by Alva Day.)

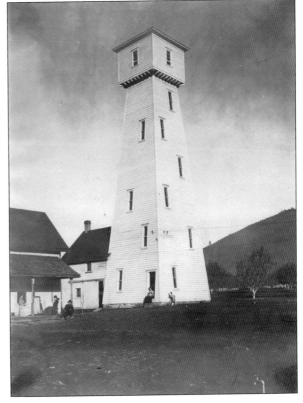

The Liberty Home was located in the Pine Grove area of the south Hood River valley. By the early decades of the 20th century, Albert Mason's Liberty Home Orchards was the model for would-be Hood River valley orchardists to emulate. The 85-foot water tower provided water and also functioned as a landmark. Mason himself was a noteworthy orchardist, according to the 1907 report by the Oregon State Horticulture Board, which read, "every tree was hand-thinned and thoroughly sprayed all season, and the result was only sixty-four wormy apples in 1100 boxes."

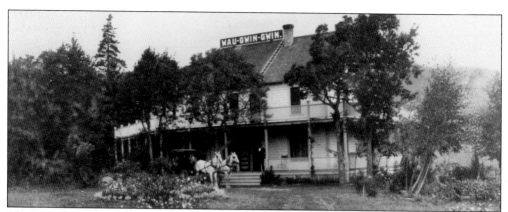

The Wau Gwin Gwin Hotel was the original Columbia Gorge Hotel. The name comes from a Native American word for "rushing water." This is fitting, since it is situated where Phelps Creek leaps over the cliff and falls 207 feet to the Columbia River below. Bobby Rand built this hotel, boasting three stories and porches all around, in 1904. It had two parlors (one for ladies and one for gentlemen) and 20 rooms with gaslights and bathrooms. Portland residents especially were fond of spending their summers here. Rand had a working agreement with the steamboat captains, who would pull into the dock below the hotel and toot their whistle for each hotel guest that disembarked. This signaled Rand's staff the appropriate number of beds to prepare. The hotel was torn down in 1921 to allow for the construction of the Columbia Gorge Hotel.

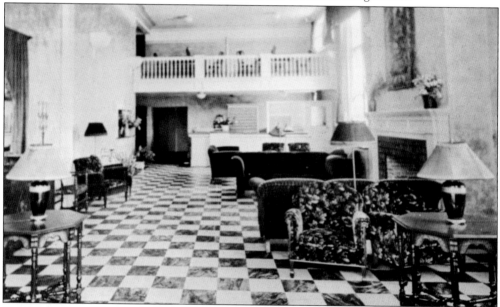

On the corner of First and Oak Streets sat the Mount Hood Hotel, now known as the Hood River Hotel. This fine lodging establishment was originally built in 1881 by T.J. Hosford. The building was very plain, with no frills or fuss. Hosford sold the hotel to J.R. Rankin, who in turn sold it to Bobby Rand. Rand set out to convert the plain building into a plush and beautiful facility. Subsequent owner Clarence Gilbert raised the roof in 1904, adding a third floor. When the Columbia Gorge Highway was completed in 1920, the hotel lost much of its former Portland clientele and fell into disrepair. But in 1989, Pasquale Barone saw this diamond in the rough and set out to restore to its former glory. The current hotel lobby looks much like does in this image, with Victorian furniture and a big, inviting fireplace.

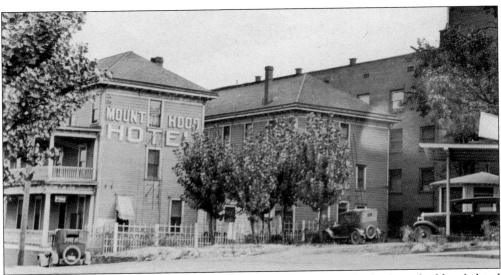

This 1928 image shows the outside of the original Mount Hood Hotel. The frame building behind the hotel, which was used as apartment lodging, has since been replaced by a parking lot for the hotel and the neighboring Pietro's Pizza.

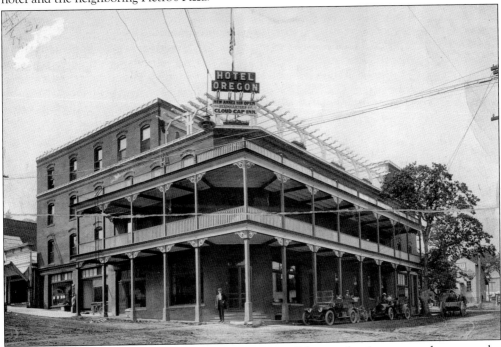

This Benjamin Gifford image of the Hotel Oregon is well known, having appeared on a popular postcard for many years. The notations on the back of this print indicate that it was the original used by the printer to make cards for the Keir & Cass Company. The cars in the front of the building do not have license plates visible, which dates them prior to 1911. The Second Street facade of the hotel houses a real estate office and a barbershop. In the window is a reflection of the sign for the *Hood River News*, located across the street. History notes that there was a beautiful terrace garden on the rooftop, which is just barely visible in this image. Today, the Naked Winery is located here.

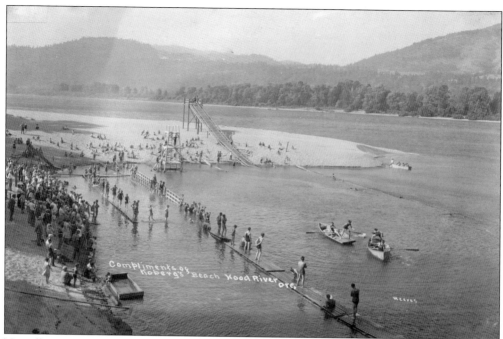

No collection of images of summer in Hood River County would be complete without including shots from Koberg Beach. Koberg Beach was more than just a rest area east of Hood River during the early 1900s. John and Emma Koberg bought the old Stanley homestead east of Hood River in 1895. They grew a variety of row crops as well as fruit, which they shipped by steamboat and train to Portland. In 1910, Koberg built a dike to protect his farmland from high floodwaters. This also created a pristine, white sandy beach, which quickly became a popular place for Hood Riverites to spend a hot summer day. It was complete with swimming cribs and a waterslide.

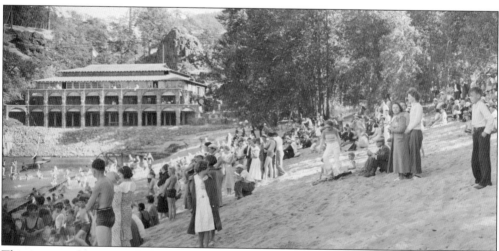

This image, taken in 1935, shows how popular Koberg Beach had become since it opened for guests. The massive stone-and-concrete pavilion was built in 1927 against the basalt cliff of Stanley Rock, overlooking the cove and beach. The first floor, with its open arches, housed a picnic area and cooking facilities. The upper level, with glass-enclosed arches, was used as a huge dance floor and concession center.

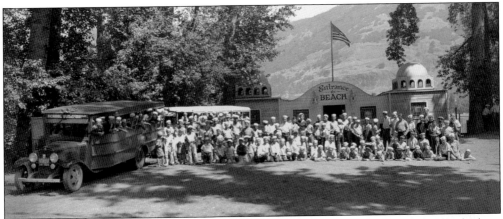

This picture shows the front entrance to Koberg Beach. It is swimming-lesson day for the boys from Parkdale in September 1937. Koberg Beach offered free swimming lessons and taught local kids about respect for the sometimes-treacherous Columbia River. The bus on the left would go up and down the valley picking up any children that wanted to spend a day at the beach and learn to swim.

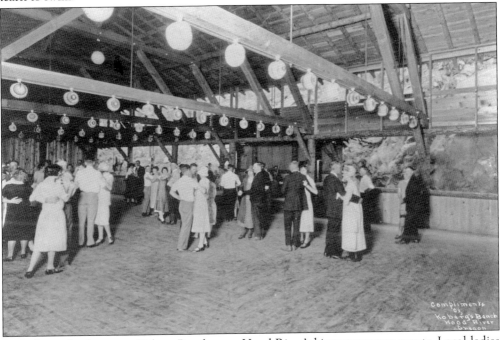

Saturday-night dances at Koberg Beach were Hood River's biggest summer events. Local ladies who were of dating age in the 1930s say that moonlight over the Columbia and music by Warner Henderson's band were "wonderfully romantic." According to an old advertisement that is now in the possession of the History Museum, the dance cost 40¢ for the men and 35¢ for the ladies. The pavilion survived the rising waters from the Bonneville Dam in 1938. Photographs from the 1950s clearly show the pavilion still intact, but with the construction of Interstate 84 in 1963, it quickly deteriorated as heavy traffic encroached on the structure. In 1982, the water level in the Columbia rose again, sounding the final death knell of this unique structure. Gone are the quiet days of Koberg Beach, replaced by the growing number of windsurfers, kite boarders, and stand-up paddleboard enthusiasts.

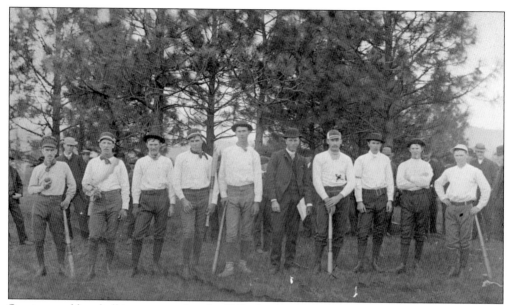

Summer and baseball just go together. In 1961, the donor of this photograph, Sadie Rich, added notes on the back, writing, "4th from the right is my father Charles D. Hayner (married Ruby Moore). Taken about 1882 at Hood River." Note the lack of gloves or helmets, despite the fact that the baseballs of that era were extremely hard.

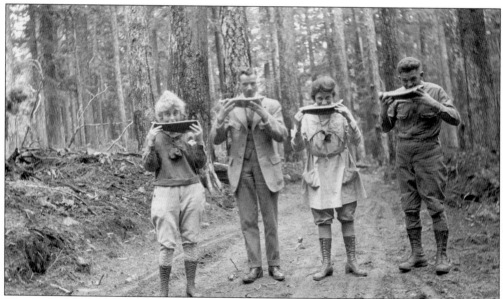

There is nothing like a cold watermelon feast on a hot summer day. This image shows three hikers and a gentleman enjoying a taste of Hood River. Remember that this was back when watermelon still had a multitude of little black seeds that had to be maneuvered around during eating. The gentleman is sure to leave this scene with watermelon juice on his nice suit. (From the Davidson Family Collection.)

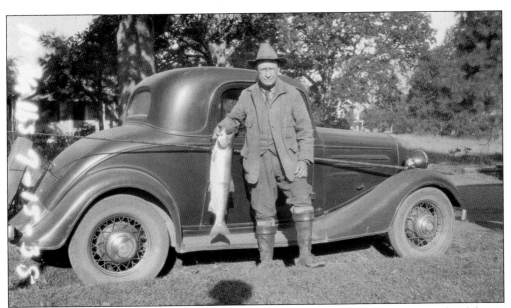

This picture shows Alva Day with an impressive catch in 1938. According to Alva, this fish was 10.75 pounds.

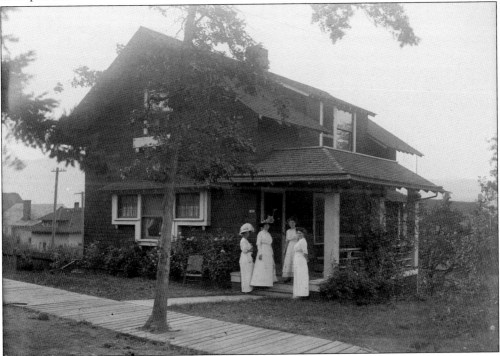

In 1975, a collection of glass negatives was found in the basement of Kresse Drug. The collection gives a great glimpse of turn-of-the-century life in Hood River, including this image of four ladies dressed for a summer outing in their white cotton lawn dresses and picture hats. Once this image appeared on the historical photograph blog, a family member from back east identified the woman standing on the porch as his grandmother Florence Amble Reed. The address was identified as 814 Oak Street.

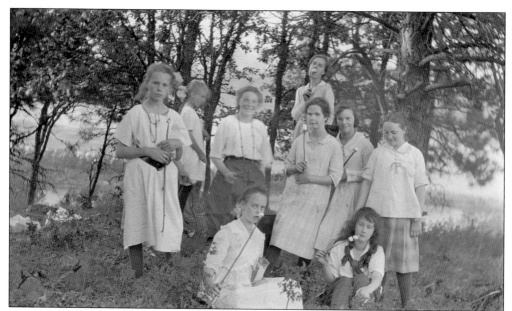

These young ladies appear to have found the perfect summer activity of roasting marshmallows. Judging by the view through the trees in the back, this image was taken on the hills southeast of Hood River. Marshmallows supposedly date back to ancient Egypt, but this image only dates back to 1915. (From the Davidson Family Collection.)

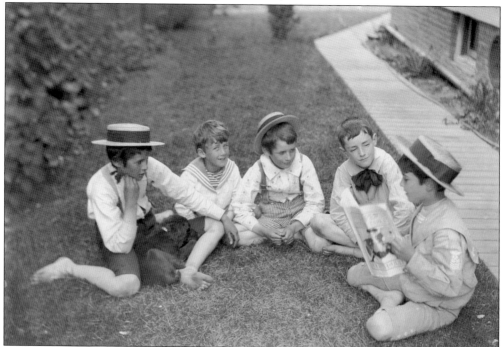

It is easy to imagine that this image may have been posed, judging by how clean and focused the boys are. Or maybe that is just a very interesting book. Their outfits were obviously purchased for a special summer occasion. At least the little dog is finding a place to relax on a hot day. (From the Anna Lang Collection.)

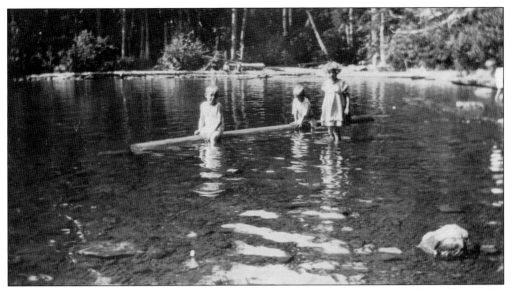

This group of kids has found the best possible way to stay cool on a hot summer day. This may be a small corner of Lost Lake, or perhaps it is one of the many rivers running off of Mount Hood. Wherever it is, the kids seem to be enjoying themselves as summer starts to wind down. (From the Max Moore Album Collection.)

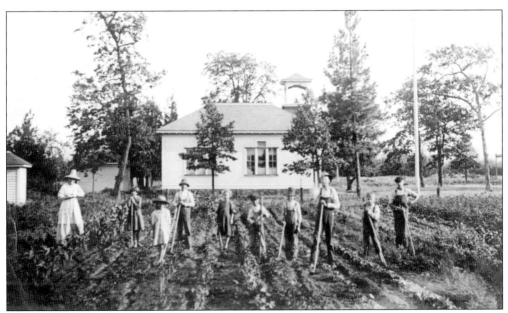

Even on the hot summer days, chores must be done. This image in front of East Barrett School shows a group of schoolchildren tending a Victory garden, which dates this picture to the mid-1940s. As part of the war effort in World War II, the government encouraged citizens to plant war gardens so they could provide their own fruits and vegetables, which would leave more produce available for US military needs.

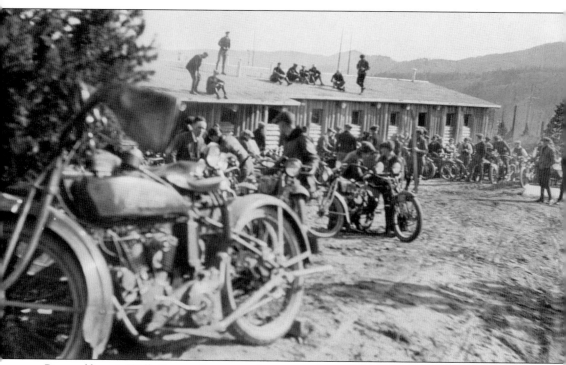

Pictured here is Wells Bennett's motorcycle party in front of the Homestead Inn. Wells Bennett, a local motorcycle enthusiast, tried to drive to the summit of Mount Hood via the Cooper Spur climbing route and very nearly made it. He was a leader among early riders. This inn was located in Parkdale's upper valley.

Four

FALL

TIME PRESERVED

*Said an Ortley to a Newtown on a
bright October day.
"Tell me, friend, where do we go
and how long do we stay?
I like it here upon the bough, for
it's been a home to me,
There isn't any better place, as far
as I can see.*

—Hilja R. Annala
excerpt from "Questions"

This excerpt, from the harvest-time poem "Questions," was written in 1943 by local resident Hilja R. Annala and was published in the Poet's Corner of the *Hood River News*. It is a humorous jab at the activity that surrounds the busy harvest season that begins for the valley orchards in early summer with cherries and ends in October with pears and winter apples. Typically, fall brings cold, crisp evenings, followed by sunny, cool days. It is a time to gather in all that has been grown and prepare for the onset of winter.

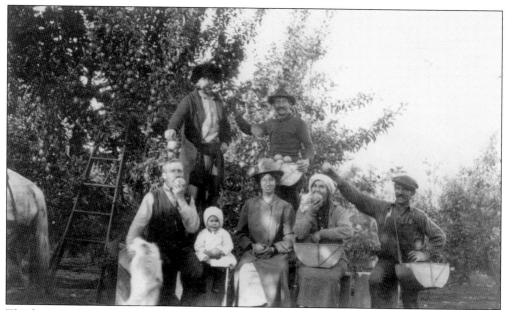

This harvest image, showing a family group picking apples, is believed to have been taken on the George Castner ranch. Everyone appears to be happy with the quantity of the harvest.

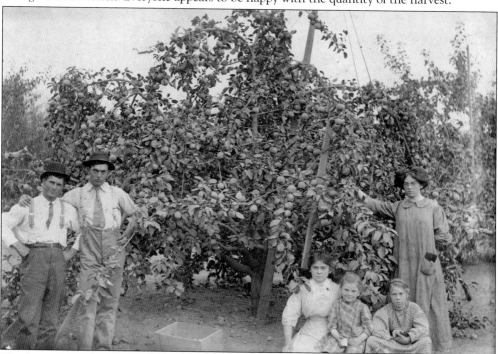

The fruit in this harvest picture are Ben Davis apples, an early-19th-century commercial variety prized for its flavor. It was also known as the "mortgage lifter" since it was a reliable grower that would not drop its apples until later in the picking season. This variety of apple is rare in modern-day grocery stores. Note what appears to be a picking ticket book in the front pocket of the apron on the woman on the right. It may have been her job to keep track of how many boxes of apples everyone picked. (From the Dorothy Cheal Collection.)

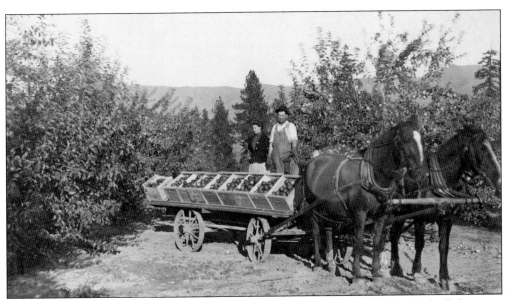

This fall image shows the wooden boxes filled with apples that have been picked off the trees. The horse team would be invaluable to get these boxes quickly to the packing shed so they could be prepared for shipping. (From the Dorothy Cheal Collection.)

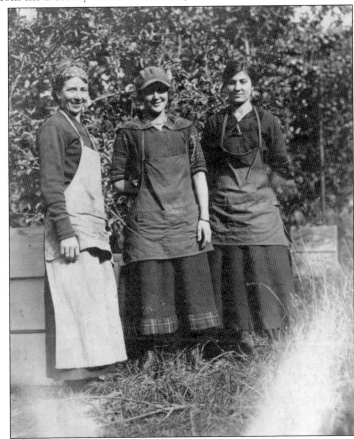

The notation on the back of this postcard image has been rubbed off over the years, but it is known that the card was produced by the Slocum & Canfield Company of Hood River in about 1902. The "Slocum" in this company name is believed to be George Slocum, who operated a book-and-stationery store in the brick building owned by his uncle E.L. Smith. He had a long-standing history of working with the fruit industry, which may have influenced his subject matter in the production of this postcard image.

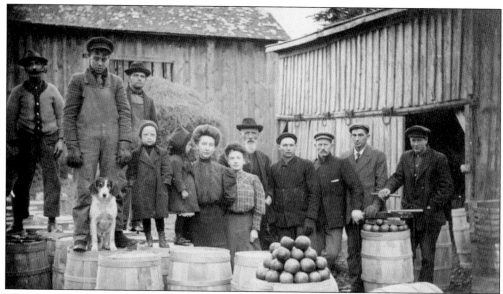

This image presents a very early apple-packing operation. Everyone, including the dog and children, is present as the apples are carefully packed into the barrels and then sealed with a lid. Note the lids stacked on the right, ready to go on the barrels. That might be the first dusting of snow on the roof in the background, as winter is quickly approaching.

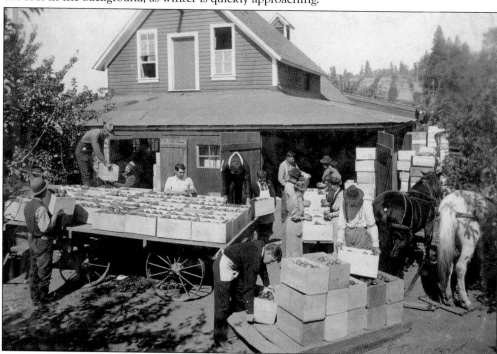

Everyone is hard at work in this picture as the apples are being sized, sorted, and packed in the wood crates in preparation for shipping. The horses are pulling a sled in from the orchard. The large wagon will be stacked with the completed boxes and taken to the Hood River docks to be loaded on a stern-wheeler headed towards Portland. This is the Albert Mason orchard that was identified in some of the summer images.

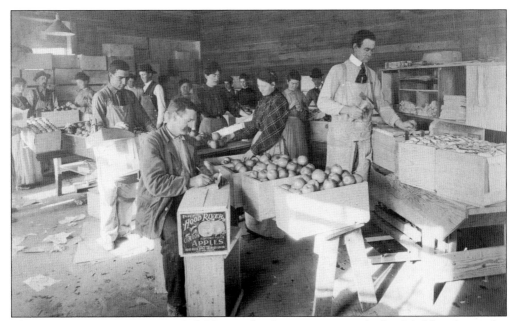

This interior view was given to Bob Nunamaker by county agent Archie Marble, who used it for a Hood River exhibit at the Oregon State Fair. It shows the process for carefully packing and wrapping the individual apples into the wood boxes. Colorful fruit labels were then applied to each box to identify which grower had supplied the apples. This label is from the Hood River Apple Growers Association.

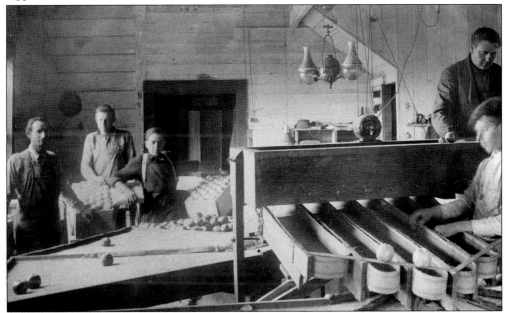

As the years progressed, more advanced fruit-handling technology was invented, much of it by necessity. This is an early Palmer grader that helped determine the size of the apples, ensuring that the packer would know how many to pack in a box and what box to pack them in. This image was captured in 1912 at the Max Welton orchard. At far left is Ed Dreske. Hal Nesbit is sitting on the far right. Standing on the right is orchard superintendent Burton Lowery.

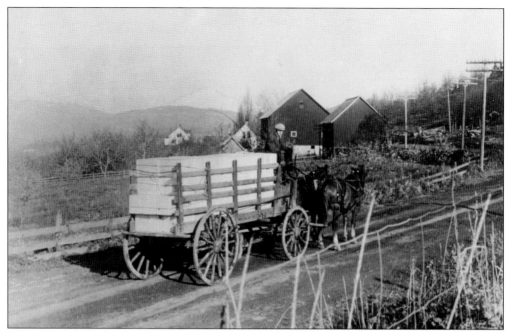

After the orchardists picked and packed the apples or pears, the boxes were loaded onto wagons, and later trucks, to be taken into town to await the beginning of their journey to market. Some went to nearby Portland, but many shipments went to the East Coast and to destinations around the world.

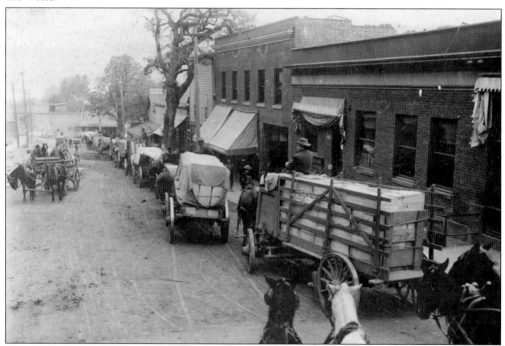

In this late-1800s image, heavily loaded apple wagons are lined up downtown as far as the eye can see, awaiting their turn to load their product onto a waiting stern-wheeler or train. This picture represents months of hard work that went into reaping this type of wonderful harvest.

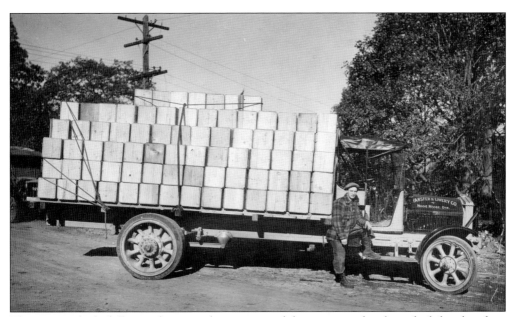

There is very little difference between this picture and the one immediately to the left, other than a few years and the change from horse power to truck power. This image still shows the bountiful harvest, packed and ready to be shipped off to be enjoyed by shoppers across the United States. By this time, Hood River apples had become synonymous with the best apples in the world.

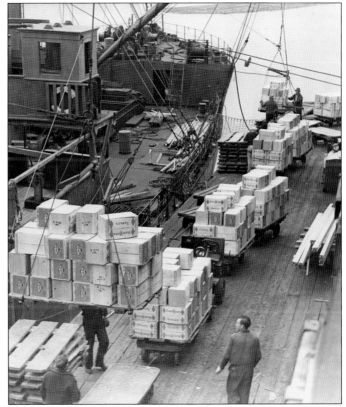

These Hood River apples are being loaded onto a ship in Portland for the continuation of their journey to destinations across the United States and around the world. Each box bears the Hood River label and carries with it the reputation and livelihood of a friend, family, or neighbor from the Hood River valley.

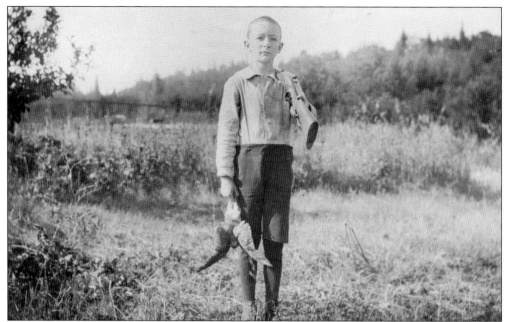

Young John Connell is pictured in 1895 with his first game bird. He shot this on the old Bowman ranch and was photographed by Winifred Marsh. Years later, as an adult, John gave this picture to the Hood River Historical Society to be preserved for future generations.

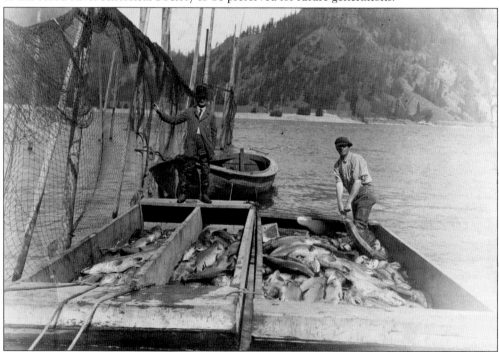

According to the notation on this 1918 photograph (taken by LeRoy Childs), this image shows T.F. Johnson, city sheriff, on a very busy day on the Columbia River. It is uncertain which of the two men is Johnson, but it is clear that this was a wonderful day for salmon fishing. The image is taken looking north, with Washington visible on the other side of the river.

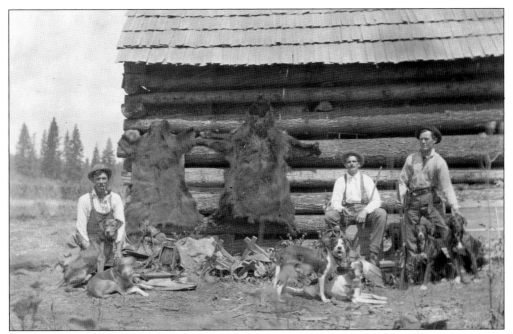

This image displays several of the key elements required for a successful bear hunt. One needs a good gun, great hunting buddies, and faithful hunting dogs. Bears were much more prevalent when early settlers were establishing their homesteads; they were hunted for their meat, grease, and warm hides, all of which were essential to pioneer life.

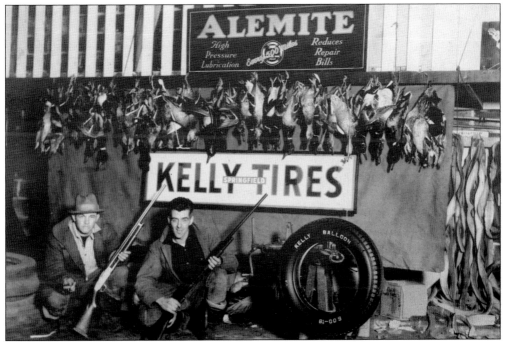

This hunting picture was taken much later, in the 1930s. It shows buddies Carl Rand (left) and Marion Nesbit (right) with their catch of the day: ducks. The photograph was donated to the History Museum by Hal Nesbit.

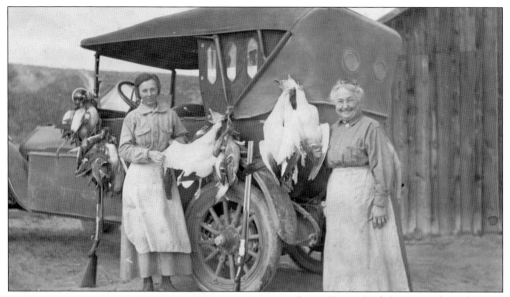

Susan Dean (right) seems pleased with their success of a recent hunting trip to Harney County in 1910, but her granddaughter Olive Shepler seems a little less thrilled. Now the hard work begins, as all of these birds will have to be gutted, scalded, and plucked before they can grace the dinner table. Mrs. Dean's husband, Oliver "Commodore" Dean, was well known in Hood River as the operator of a ferry service to White Salmon between 1903 and 1919. His ferry, the *Ollie S.*, was named after Olive.

The gathering of friends has always been an important part of community life. This image shows the Hood River Reading Club. Picture are, from left to right, (front row) Edward "Sonny" Bennett and Genevieve Collie; (second row) Sadie Bennett, Helen Wyland Donohoe Hallock, Inez Guttery, and Nell Smith; (third row) Gladys D. Reed, Ida Taft, Ella Blanchard, and Margaret Tompkins. It would be interesting to know what their favorite books were in their day.

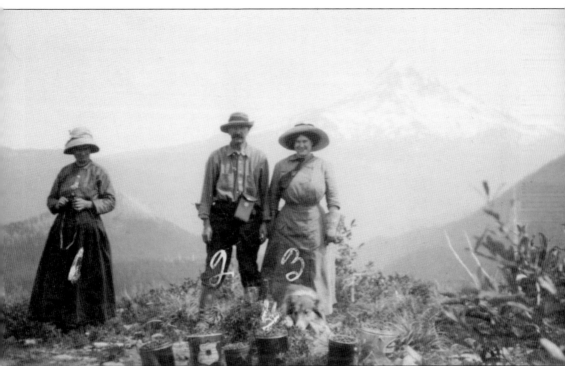

Fall in the Hood River valley also brings another kind of gathering. Pictured here in 1912, from left to right, Clara Lenz, Ralph Arens, and Arlene Wenchell Moore are gathering huckleberries just south of Lost Lake. They are joined by Shep the dog, who appears to be keeping a careful watch on all of those buckets of berries. Typically, huckleberry season runs from late August to early October. (From the Max Moore Album Collection.)

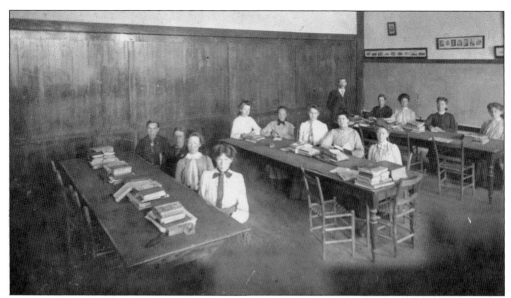

Fall also means students going back to school. This very rare image shows the inside of the Frankton School some time between 1903 and 1906. Pearl Blaylock is sitting at the center table, second from the right. She would later become Mrs. Earl Ordway, mother of Irene Brosious (who donated this picture to the early historical society members). The teacher in the back is Mr. Brown.

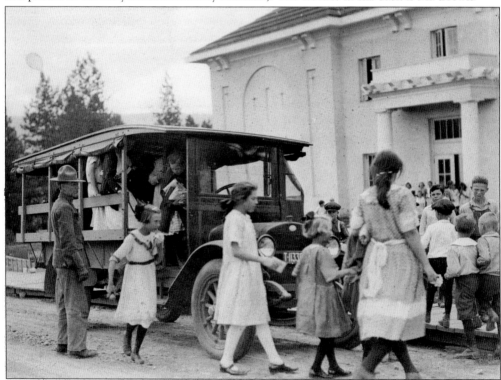

These students are being dropped off at the Odell Grade School by bus driver Harry Caughey. This school building, still owned by the Hood River School District, is now boarded up and used for surplus storage. (From the Caughey Collection.)

Pictured in 1917, this is the first Pine Grove bus. The Oldsmobile is sitting in the middle of Oak Street at First Street; in the background, one can see the recently completed Mount Hood Hotel Annex (left) and the Yasui Store (right).

This is the 1922 Hood River High School chemistry class. Judging by the heavy aprons, vials, and bottles, this is sure to have been an interesting class.

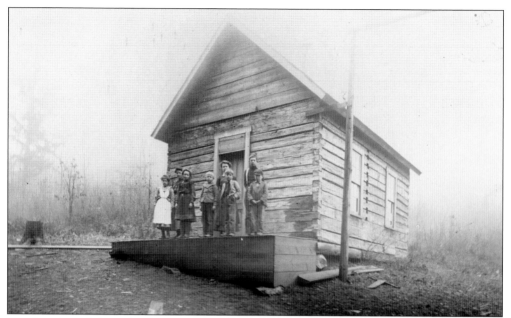

The location of this school is uncertain, but it is noted as being "near Mount Hood." Of the faded list of identifications on the back of the photograph, all that remains legible is the name Bella Walters. Notice the rough-hewn log construction, which may account for the stump clearly visible on the left. The seven students of varying ages, one teacher, and one room are indicative of early Hood River County schools.

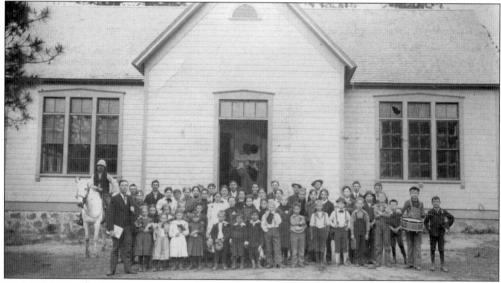

This image shows the Pine Grove School some time in the early 1900s. Abraham Lincoln's face can be made out on the book held by the teacher, Mr. Sisson. The man on the horse is Hans Lage, whose farm is just around the corner from the school. There are names of all the students listed on the back of the image, including many that are recognizable as names of early Pine Grove families, including Wells, Wishart, and Paasch. A guest at the History Museum's website stated that the boy holding the drum on the left had the responsibility of "drumming" the students to school, calling everyone to line up and prepare to enter the halls of learning.

Five

WINTER
TIME SLEEPS

Then Santa Claus comes with his prancing reindeer
And makes December the jolliest month in the year,
For the stockings he finds hanging all in a row,
Are filled to the top with a great overflow.
Then on Christmas morning with shouts of delight
The kiddies find gifts which he left in the night.
Then ho! For old Santa and glad Christmas day;
We'll laugh, be happy and chase cares away.

—Sallie A. Carson
excerpt from "December Joys"

Winter in the Columbia River Gorge sometimes heralds tough times and harsh realities, as in 1919, when hundreds of apple trees succumbed to severe temperatures of 27 degrees below zero. When the orchards were replanted, many switched to hardier varieties of pears, changing the direction of the fruit industry forever. But winter also brings families together for the holidays and a variety of winter sports. Evenings were spent pouring over seed-and-plant catalogs, dreaming of spring.

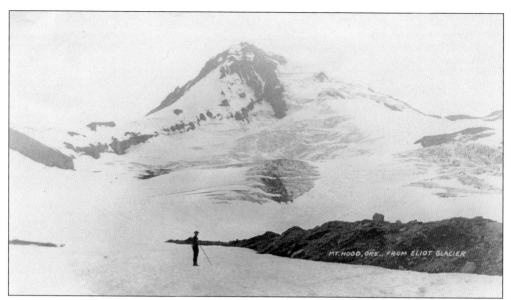

A lone climber is visible in this photograph of the summit of Mount Hood, taken from Eliot Glacier. Statistics from 2007 note that about 10,000 people per year attempt to climb Mount Hood. The ascent is made dangerous by avalanches and drastic, sudden changes in weather. Since records have been kept, over 130 people have lost their lives attempting this climb.

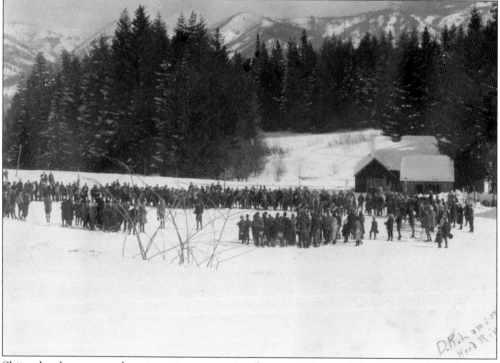

Skiing has been a popular wintertime recreation for over 100 years. This image is from the early 1920s and documents what is thought to be the very first official ski race in Hood River. The photograph was taken at the Goldsburg ranch by D.R. Lamson, a Crag Rat from Hood River. It is hard to tell how many of these people are race participants and how many are eager spectators.

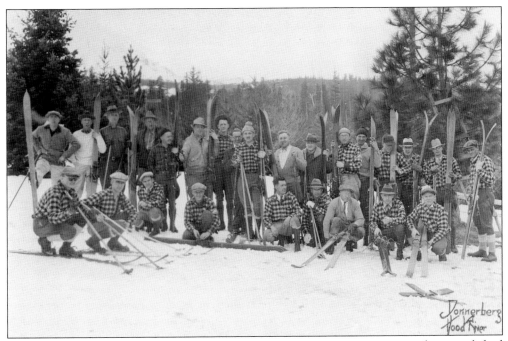

The Crag Rats, photographed by Fred Donnerberg, were very competitive and accomplished skiers who loved to compete against any challenger. A list on the back of this image has some very familiar names, including Don Lamson, Herman Kresse, and Sulo Annala.

The familiar checkered shirts worn by these men designated them as Crag Rats. In this 1950s image, they are measuring the snow depth and water content. Knowing how much water is stored in the snowpack helps valley fruit growers prepare for what might be available to be used as irrigation water in the summer months. These men are indentified as, from left to right, Bill Bryan, Wilson Applegren, Elwood "Tweet" Samuel, Norman Hukari, and Jim Hukari. (Photograph by Bill Bryan.)

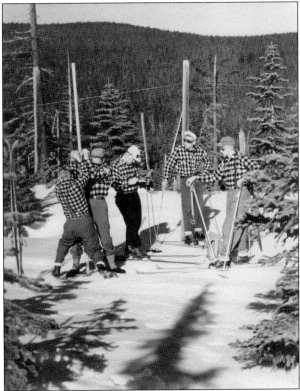

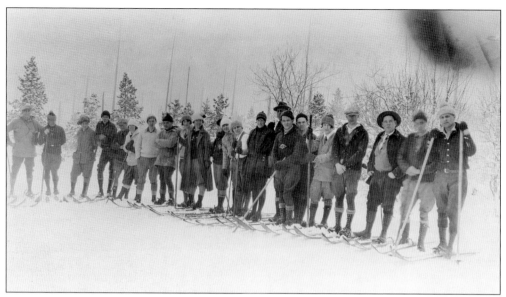

This is a very early ski club image. Notice the very high laced boots and the short ski pants.

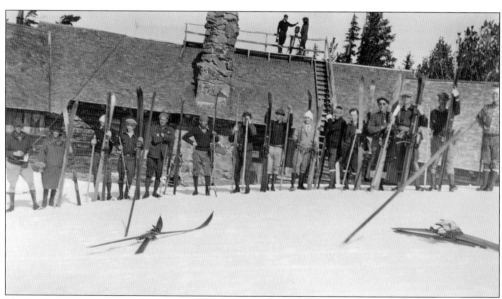

Skiing and mountaineering were very popular in the 1920s and 1930s. Here is the Hood River Ski Club in March 1926 preparing for a race. They are standing in front of Cloud Cap Inn, where they most likely have just powered up with coffee and breakfast. Skiers would ski to Cloud Cap and then continue on up Mount Hood. Note the man on the lookout with the tripod, who seems to be an early sports photographer.

In the early days of skiing on Mount Hood, there were annual ski tournaments on the north side of the mountain and at Government Camp on the south side of the mountain.

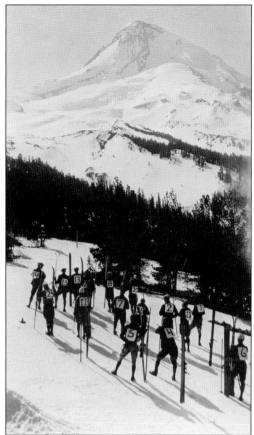

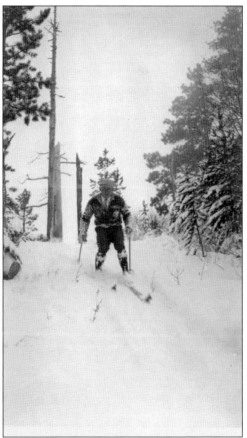

This is Novin Coulter free skiing in fresh powder snow. This pastime remains popular in modern-day Hood River County.

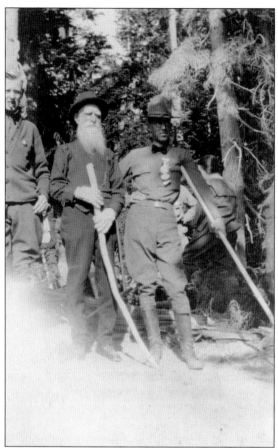

While the older gentleman in the center of this image might resemble the fictional grandfather in *Heidi*, he is in fact Samuel F. Blythe, who lived to be 86 years old and climbed Mount Hood many times during his life. He was an editor of the *Hood River Glacier* and, as noted in his obituaries, was loved and respected by many in the community.

One can almost feel the cold in this picture of the Mount Hood Tavern. The establishment, owned by George and Jeannie McMullen, was located at the junction that heads off to Cooper Spur. The couple's dog can be seen to the left. It is unlikely that many guests came to the tavern on this day.

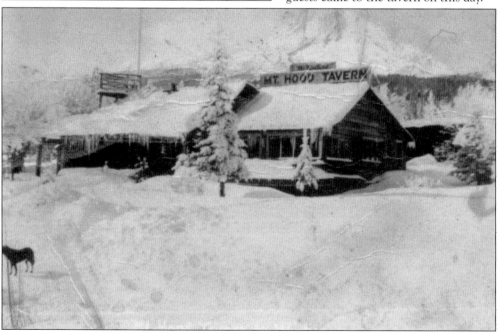

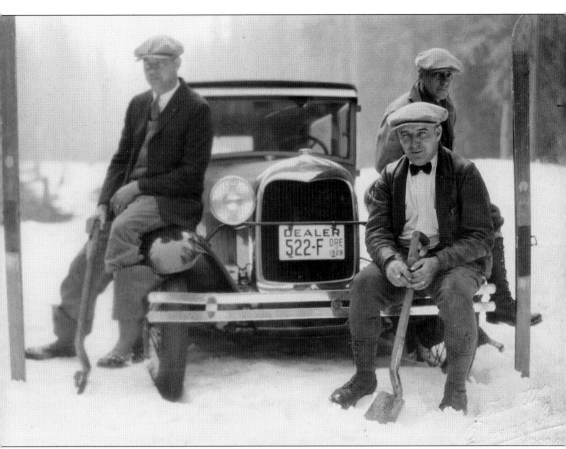

Hood River photographer Fred Donnerberg captured this image of Norvin Coulter (seated in the front) and two friends with their Ford Model A in 1928. It may have been that this was some type of staged photograph to advertise Coulter's automobile dealership, or perhaps it was to show how the tires on this car would handle in adverse winter conditions. Either way, the men do not seem too concerned about the weather or the need for their shovels.

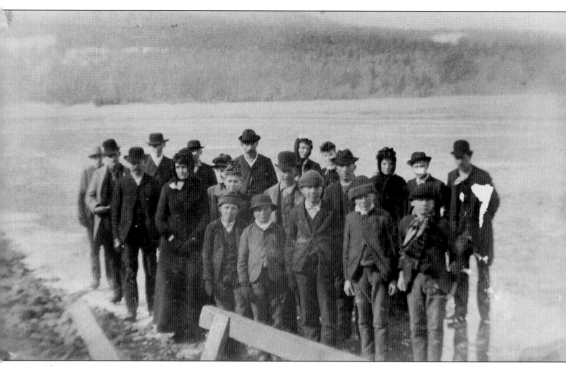

This image shows a Columbia River skating party in the 1880s. With only 17 families occupying Hood River in 1880, this gathering quite possibly accounts for a good percentage of the entire population. A *Hood River News* article from 1950 described early skating, saying, "one of the best sports of all was for two people on skates to hold onto an umbrella and when the wind was blowing good and strong from the east, you'd skim down the Columbia River ice a mile or more." Maybe this was actually the first form of windsurfing documented in Hood River?

This image shows how deep some of the snow can be around the homes in the Hood River valley. The use of the snowshoes and the ladder would help these two young men get around between the house and the barn. (From the Imai Family Photo Collection.)

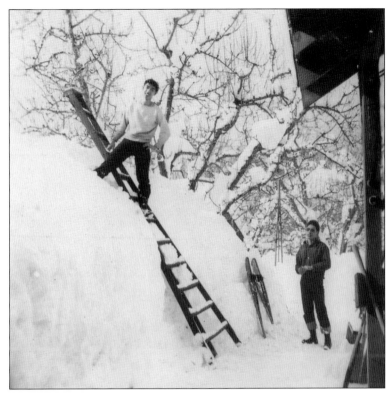

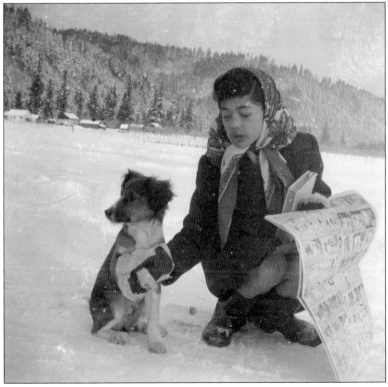

This young lady appears to be examining the dog's foot, perhaps concerned about its feet being too cold to make it back home (visible in the background). The newspaper comics in her hand indicate that this may have been a Sunday. (From the Imai Family Photo Collection.)

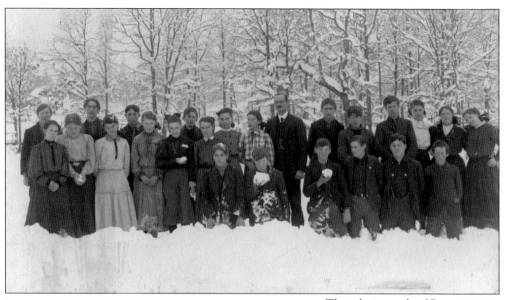

This photograph of Barrett School is believed to date to 1905. Whatever the year, it is obvious that this image was taken during the winter months. The Barrett School opened in 1879 with Mrs. C.L. Henderson as teacher in the one-room schoolhouse. Classes ran six to eight months, depending on the money available to pay the teachers. The original old wood-frame building was torn down in July 1911. The back of this image notes many of the students in this photograph, such as Earl Moses (front row, left) and Carrie Camp (second row, left).

What little girl would not love to have a tree house like this? This image from 1912 shows Dr. E.E. Ferguson and his daughter Ruth. The note on the back says this was the "summer bedroom," but one can easily recognize by the heavy outerwear that this image was not taken during the summer months. The tree house was described as being 26 feet from the ground. The Fergusons lived at Alameda Ranch on Alameda Way in Hood River.

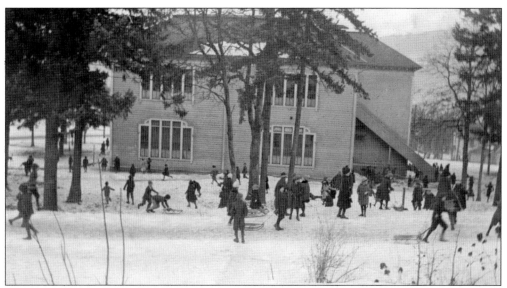

Wintertime recess at the Old Park Street School is reflected in this photograph. In a 1946 report, Mary Bissett noted that the Park Street School was built in 1896 at a cost of $9,000 and that it contained nine classrooms. It was eventually torn down, and in its place now is a beautiful city park where children can still enjoy playing in the winter snow.

In this 1913 winter image, Gertrude R. Stanton (left) and Jessie Stockwell (right) are taking a quick break from their sledding by Park Street School.

In this 1915 or 1916 photograph, there is a heavy cloak of ice on the surge standpipe at the old Powerdale Plant. The plant was essential to early fruit growers, providing services for flour mills and food-processing or canning facilities in the region. The ever-expanding agricultural industry brought with it an increased demand for electrical services. This plant was eventually torn down and replaced with a modern, 6,000-watt-generating plant, which was dedicated in 1923. (From the Max Moore Album Collection.)

It only takes three to four inches of heavy, wet snow, followed by freezing temperatures, to result in severe damage for valley fruit trees and berry plants. Over the past century, there have been recurring episodes of harsh winter seasons that, in essence, changed the focus and direction of the varieties of crops grown. Farmers have continually strived to ensure that their plants and trees could withstand the sometimes-unforgiving winter weather of Hood River County. This image shows a more mature tree covered with about a foot of snow; one can only hope it did not result in heavy loss for the orchardist.

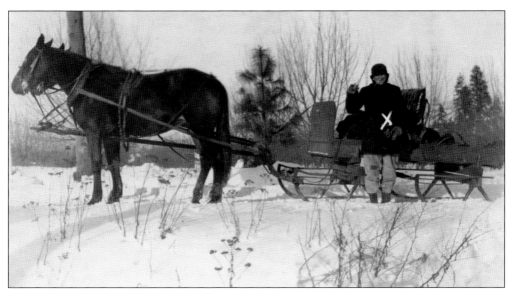

In this 1913 image, Max Moore appears to be waving at the camera as if to say, "it's cold out here." He is actually holding an insulator. Max, in his capacity as lineman for the Pacific Power & Light, is checking power lines, using a horse and sleigh to reach remote locations in the heavy snow. (From the Max Moore Album Collection.)

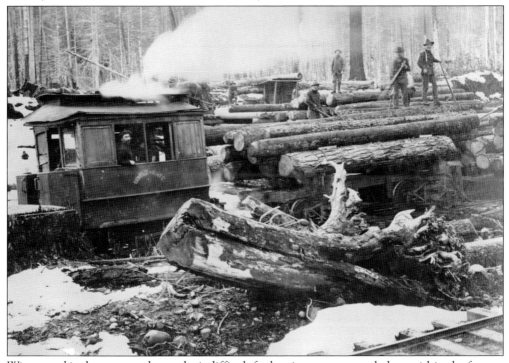

Winter and inclement weather make it difficult for logging crews to work deep within the forests. This image shows the Oregon Lumber Company preparing to load cut timber onto a Mount Hood Railroad train car for transportation to the mill. The tracks are visible in the lower right corner. As indicated by the lettering painted on its side, the tractor cab appears to have been named *Little Kate* by the crew.

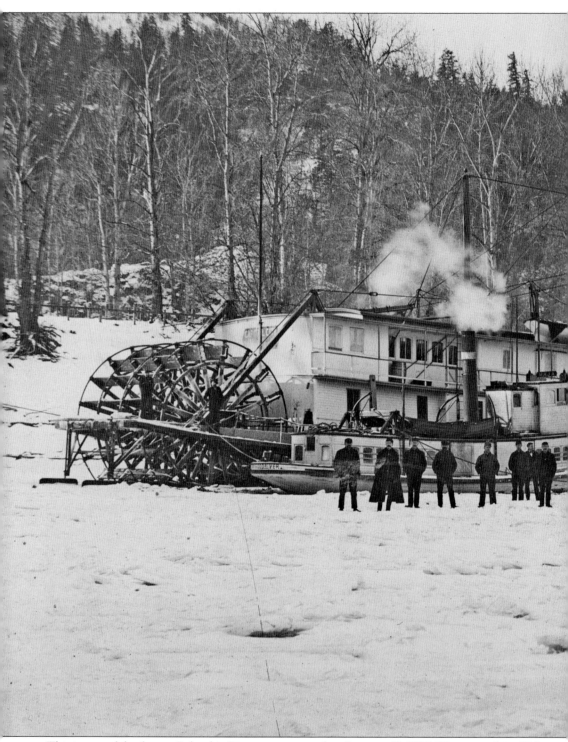

This image of the frozen Columbia River was captured on January 17, 1907. The steamships *J.N. Teal* and *Capital City*, along with the tug *Maja*, are frozen in the shelter of Stanley Rock, near Koberg Beach. With so much of Hood River County's commerce dependant on river transportation,

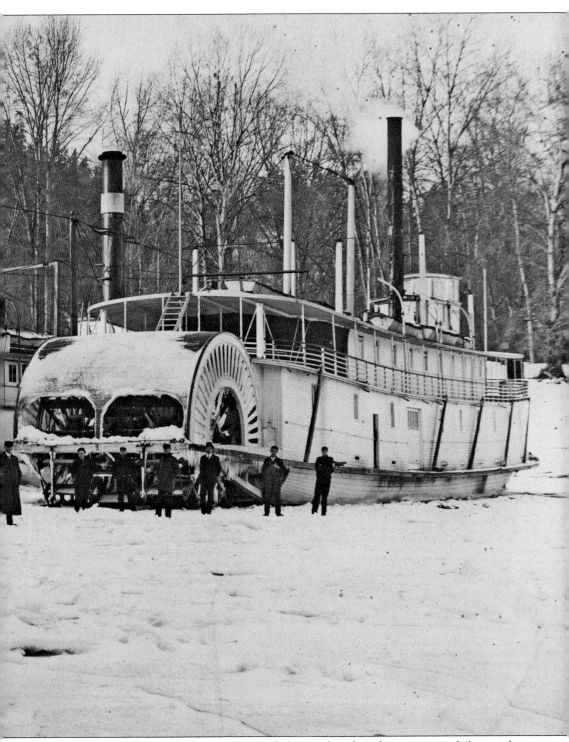

it is a sure thing that there were some empty shelves and cupboards in town until the weather warmed a bit and transportation resumed.

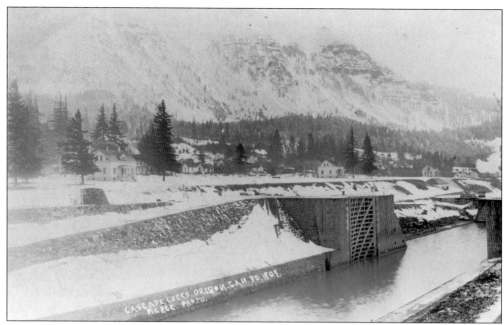

The small community of Cascade Locks often gets the brunt of the heavy precipitation in the area, as it is located just west of the city of Hood River at the crest of the Cascade Mountains in the Columbia River Gorge. This image, donated by Viola Gorton, was captured in 1909 and shows a cold, wet, snowy view of the locks.

Waiting for the train on this day would have required a set of heavy long johns. During the winter months, train travel would have been the only way for communities such as Cascade Locks to stay connected to the outside world. But even winter train travel can be difficult in the Columbia Gorge. In 1884, a Pacific Express train carrying 148 passengers and crew left The Dalles heading west towards Portland. A blizzard trapped the train between two avalanches with 25-foot-high snowdrifts. A relief party finally reached them on Christmas Day, and the train reached Portland three weeks late, on January 7, 1885.

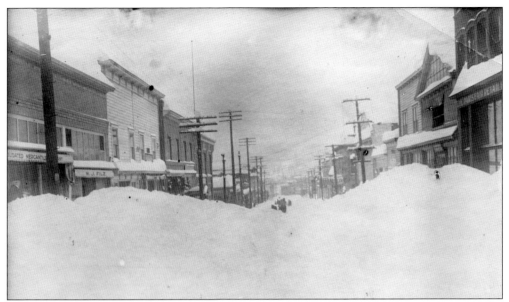

Without the advantage of modern snow-removal equipment, a winter like the one shown in this downtown Hood River image would bring pretty much everything to a halt. There are a few brave souls that have defied the weather, such as the man standing in front of the Consolidated Mercantile Company (to the left) and what appears to be a group of people coming down the center of the street. With this much snow downtown, upper-valley communities, such as Parkdale and Mount Hood, are sure to be struggling to dig out their homes and barns.

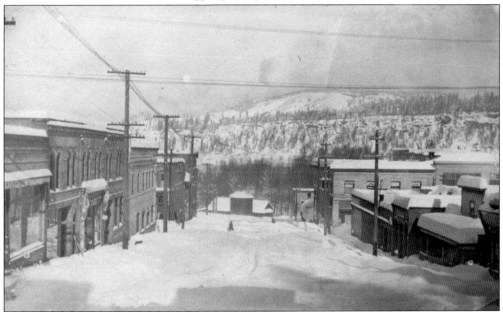

This image was taken in the winter of 1915 and 1916 on First Street, looking north from State Street across the Columbia River to the Washington hills. Max Moore noted that, in some places, the snow was six feet deep when the storm was over. The train depot is in the center of this image, with the Hood River Hotel on the left of the intersection. The fire station is located on the right. (From the Max Moore Album Collection.)

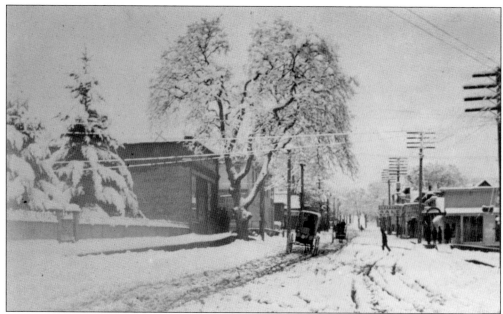

There are so many interesting details in this early-1900s image. This is Oak Street, which, with all the old grand oak trees still in place alongside it, gives a better understanding of how it received its name. On the right is the Crowell Store, with a "Clearance Sale" sign clearly visible. With only hand shovels to clear the streets, it would have been very difficult traveling both by foot and with the lightweight horse-drawn buggies seen in the center of the picture.

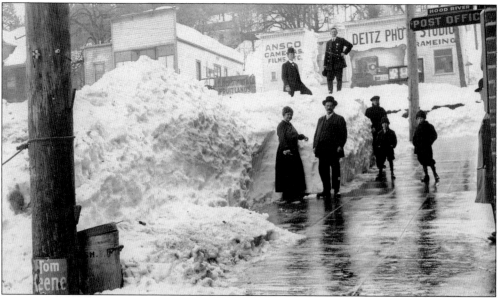

This February 8, 1916, image is actually a postcard published by the Slocom & Canfield Co. in Hood River. This is an example of what is considered the golden era of American postcards. During this time, the American public became obsessed with capturing day-to-day life (such as in this snowy photograph, taken in front of the post office on Second Street) and sharing the scenes with friends and family members. By the end of World War I, the postcard craze died down and was replaced by the telephone as a mode to help people to stay connected.

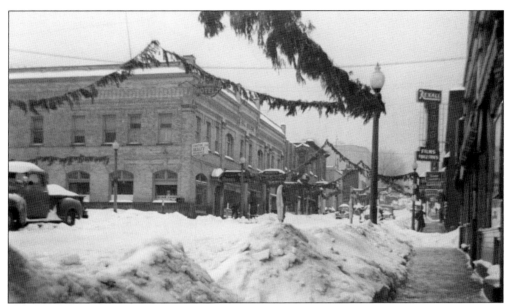

Hood River definitely received a White Christmas in 1950, as documented in this image of Oak and First Streets. One visitor to the Hood River historical photograph blog, Charlott, recalls that a local farmer had to collect the children from the Pine Grove School with a sled and tractor to get them home. The snow piled up so high her father had to shovel the roof; it was so high under the eaves that the children could sled from the top of the house, into the snow piled to the gutter, and right on out into the front yard.

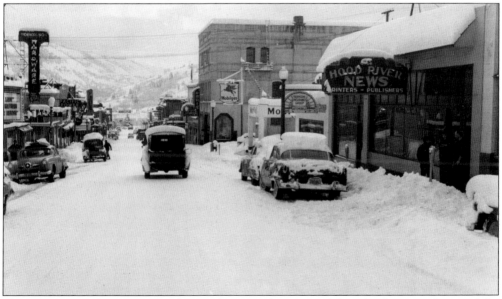

The exact date of this image is not known, but it can be narrowed down by the years of automobiles and the names of the visible businesses. In 1952, Robertson Hardware (on the left side of this eastward view), at 406 Oak Street, was featuring freezers on sale. Note there are no electric poles, but plenty of big signs and parking meters. Upon closer inspection, the word "plumber" can be read on the back of the pick-up truck in the center; maybe he is on the way to fix someone's frozen pipes.

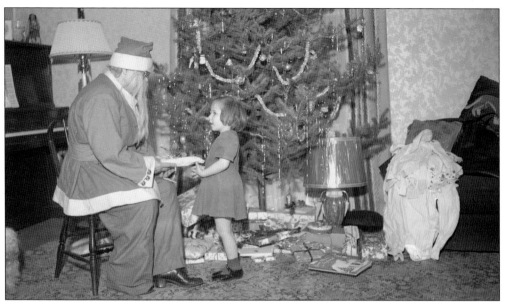

With over 2,700 images spanning decades of Hood River County history, the Alva Day Collection provides an in-depth insight into day-to-day life. This image, taken at 8:40 p.m. on Christmas Eve, 1951, captures this little girl's obvious delight at her visit with Santa. One might wonder whether they opened their presents on Christmas Eve or Christmas morning. (From the Alva Day Collection.)

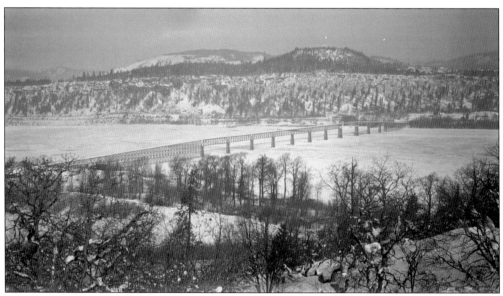

Taken on February 9, 1929, this print clearly shows the Oregon-Washington Bridge on a cold and frozen winter day. This bridge was built by the Oregon-Washington Bridge Company and crosses between Hood River and Bingen, Washington. It opened in 1924 and spans close to one mile across the Columbia River, with a vertical clearance of 67 feet that increases to 148 feet when the center span is lifted for tall-ship access. The bridge is now maintained by the Port of Hood River and costs $1 per automobile to cross. (From the Alva Day Collection.)

BIBLIOGRAPHY

Masiker, C.C. "The Land of the Bunchgrass." The History Museum Collection, 60.013.001, 1900.

Carson, Sallie A. "Spring Is Just Around the Corner." *Poetry by Sallie Carson.* Alberta Carson Kirkwood, ed. Hood River, OR: Maranatha Press, 1959.

———. "December Joys." *Poetry by Sallie Carson.* Alberta Carson Kirkwood, ed. Hood River, OR: Maranatha Press, 1959.

Annala, Hilja R. "Questions." *Hood River News,* 1943.

Beltz, Charles Harvey. "The Cool, Shady Path." Self-published, 1943.

Discover Thousands of Local History Books
Featuring Millions of Vintage Images

Arcadia Publishing, the leading local history publisher in the United States, is committed to making history accessible and meaningful through publishing books that celebrate and preserve the heritage of America's people and places.

Find more books like this at
www.arcadiapublishing.com

Search for your hometown history, your old stomping grounds, and even your favorite sports team.

Consistent with our mission to preserve history on a local level, this book was printed in South Carolina on American-made paper and manufactured entirely in the United States. Products carrying the accredited Forest Stewardship Council (FSC) label are printed on 100 percent FSC-certified paper.

MADE IN THE
 USA